Women, Violence and nonviolent change

Women, Violence and Nonviolent Change

EDITED BY

Aruna Gnanadason
Musimbi Kanyoro
Lucia Ann McSpadden

WCC Publications, Geneva

Cover design: Stephen Raw

ISBN 2-8254-1169-8

© 1996 WCC Publications, World Council of Churches,
150 route de Ferney, 1211 Geneva 2, Switzerland

Printed in Switzerland

Table of contents

Introduction

In all regions of the world, women are dealing with the violence they confront through nonviolent actions. From the Sri Lankan Mothers of the Disappeared to the British Greenham Women Everywhere to the Kenyan Mothers in Action to Gabriela in the Philippines, women are organizing to confront the violence which threatens their lives.[1]

The global reality of violence against women is that women are not only victims but also astute, creative and successful actors in responding nonviolently to it. Both these factors shape the context in which women work, live, struggle, love and hope.

While "conflict-resolution" in response to increasing violence between states has a high profile these days, what are not often heard are women's voices, relating their own experiences of violence, attesting to women's truths in conflict situations, asserting the need for changes important to women. Such perspectives are typically not reflected in international or formalized efforts of conflict resolution. Much is lost because of this silencing, not least — as the case studies in this volume aptly illustrate — because women's responses to violence are often effective.

The Ecumenical Decade of Churches in Solidarity with Women, launched by the World Council of Churches in 1988, enlists the churches' response to women in their struggles against oppression and for a more humane, just and peace-filled world. The Decade has been embraced by women in the churches, providing opportunities for them to speak truth to power, to share particular truths from vastly different contexts, to grow in solidarity and in understanding.

The women who speak through these pages cause us to rethink our own assumptions and extend our definitions of violence and nonviolence. They lead us to see the linkages between different forms of violence, to understand that the private is public, that the individual experience is also a community experience. They give first-hand insight into how women can organize to combat violence towards women and in so doing care for the health of their societies.

These case studies and the analytical reflections preceding them grew out of the Women and Nonviolence project of the World Council of Churches, the Lutheran World Federation and the Life & Peace Institute of Uppsala, Sweden. Inspired by the Ecumenical Decade of Churches in Solidarity with Women, the project was meant to show both the interrelatedness of the many forms of violence against women and the specific contributions women's organizations bring to the search for peace and justice.

As part of the project, a conference bringing together 50 women from almost 30 countries was held in Manila, in November 1993. The meeting was facilitated by Gabriela, an alliance of more than 200 Filipina women's organizations. Surrounded by the extreme poverty and pervasive violence in the Philippines, participants were moved by the strength, dedication and the energy of Filipina women. The range and variety of women's work in the Philippines spoke eloquently of the effectiveness of their dedication and energy. Against the backdrop of the ever-present paradox of poverty and hope, of "people hanging on to their dreams" (as one participant put it), the dignity of the people shone through.

This volume, envisioned at the Manila conference, shares some of those voices through thirteen case studies and three analytical reflections. The case studies, from locations as diverse as Nepal and the Netherlands, Cameroon and the United Kingdom, Vietnam and Canada, show how social and cultural contexts shape women's experiences of violence, their analysis of its causes and the ways they choose to stop the violence.

Some of the ways women have responded to violence are more institutionalized, becoming visible political movements for resistance or advocacy such as the Greenham Women or the almost-spontaneous anti-arrack agitation initiated by the women of Andhra Pradesh in India. Some, like Women for Peace in The Netherlands, become organizations for education and action. Some ways of responding are more pastoral, such as the conciliation teams in Vietnam.

All, however, choose nonviolence as the way to respond to violence, whether it is experienced as domestic violence, military violence or social and cultural violence. Thus these case studies give a strong voice to women's nonviolent creativity in working to bring into being a more peace-filled, just world for themselves, their families, their communities, their nations and finally for us all.

The inter-relatedness of violence in its different forms is dramatically clear in the experiences of women. Economic violence, frequently the consequence of "structural adjustment" policies imposed by intergovernmental financial agencies, often leads to governmental oppression and military violence when opposition arises. Such oppression, ripping apart communities and targeting leaders, places women in an increasingly vulnerable economic and social position. The severely limited economic prospects for the average person in the Philippines, for example, lie behind the exploitation of girls and women as foreign domestics, prostitutes and bar girls.

Social and cultural vacuums created by war, violence, the destruction of communities, economic change and political oppression provide a foothold for religious fundamentalisms — Christian, Muslim, Jewish, Hindu. As these forces increase in strength, they shift the social forces affecting women. The breathtaking rapidity of economic and political change in Eastern Europe, for example, has ripped away social and economic protections for women while increasing the influence of religious fundamentalism. "I'm afraid that the 'new world order' is stabilizing patriarchy," said one Eastern European participant in Manila.

War is of course by definition violent; and its violence increases the vulnerability of women. Women have been used over the centuries as sexual weapons and objects of violence between warring factions, a reality brought to life in the experiences of Korean "comfort women" in Japan during the second world war and in the raping of women in the former Yugoslavia. A Haitian woman attending the Manila conference spoke poignantly of how the violence of war comes close to the lives and homes of women: "I'm afraid... I'm afraid because I have three daughters, and I fear that one of them will be raped while I'm attending this meeting. The situation is desperate... There's no protection for Haitian women."

As women confronted with domestic, economic, political or military, social or cultural, ethnic or racial and religious violence respond — in ways as diverse as their settings and their resources —

their strength comes from their commitment to life rather than death, to peace rather than war, to the future for their children, their families, their communities. Their strength also comes from linking with others, building strength from their vulnerability. The Haitian woman who spoke of her fear for her daughters continued, "I'm here because, without international solidarity with Haiti, nothing will change."

Women in Somalia use their connections, through husband and children, to more than one clan to work to end the violence between those clans. Women working within the intensely patriarchal societies of Nepal and Nicaragua find strength in broad networks of women who can support each other. Indigenous women in the mountains of the Philippines organize with men to counter the threat of encroaching lumber companies and then organize with other women to develop new social rules of acceptable conduct aimed at reducing violence linked to excessive drinking by men in their communities.

Women's efforts are often invisible, remaining hidden behind and within cultural constraints. Yet some, especially in the North and West, are open and confrontational. Some efforts are composed solely of women who deliberately distance themselves from men and the social system they represent. Others intentionally include men, recognizing a need to build community while confronting violence within it.

The range of these efforts, invisible and visible, cooperative and confrontational, is amazingly vast. Sophisticated political analysis combines with direct action. Dialogue groups in Israel have led to true empathy, resulting in practical tactics to deal with injustice. A basic goal is to influence public opinion. In Mali a one-to-one education campaign was used rather than confrontation to combat female circumcision. The use of traditional social structures and cultural norms combines with innovation, thus using the "old" to guide and build the "new". In Zaire literacy for women is a threatening innovation, so women gather in homes for reading classes while doing traditional "women's work". In Somalia, under the separation and restrictions of fundamentalism, women are organizing and leading schools for girls.

Questions arise in the struggles. How can we as women prevent violence? Can change be effected from within the structures or from the outside only? How do we avoid being co-opted into the patriarchal structures of our society? How can men and women live and work together in this world in a just and equal way? How do we build a world *together*?

Support, understanding and hope sustain women in their search for the answers to these and other questions, in their nonviolent struggles against pervasive violence. Given the inter-relatedness of much of the violence, it becomes crucial on the journey to link with others who are also struggling. Humour, singing and dancing, surviving in the midst of adversity, international and local networking, family and friends, religion and faith form a web of linkages, a foundation for visioning the future — fuelling wisdom which produces discernment and hope which produces strength.

This book is an affirmation of women's contribution to nonviolent action in the face of persistent violence, an affirmation of women's faith and of women's hope. It is dedicated to all women who struggle nonviolently for a safe, just and peaceful world for themselves, for those they care about and for those they will never know.

Listen
Listen to the women
They are arriving
Over the wise distances
On their dancing feet
Make way for the women
Listen to them. [2]

Aruna Gnanadason
Musimbi Kanyoro
Lucia Ann McSpadden

NOTES

[1] From the report of the WCC-LWF-Life and Peace conference on Women, Violence and Nonviolent Action, Manila, 21-26 November 1993.
[2] Quoted by Corinne Kumar-D'Souza in her essay in this volume, pp.29ff.

ANALYTICAL ESSAYS

1. Women as Peacemakers

ELIZABETH G. FERRIS

Women's perspectives on war and peace, on violence and struggle are beginning to be recognized as offering unique contributions to the great debates on the nature of society and the international system. Papers have been written, books published and conferences organized, but most of these focus on specific aspects of women's roles in war and peace. My purpose here is to synthesize some of these perspectives and raise some questions around the subject of women, war and peace.[1]

As with most important subjects, the issues are more complex than usually depicted. Not all women are nurturing, peace-loving and anti-war; not all men are militaristic war-mongers. Women are not a monolithic bloc: they are divided by race, class, culture and life experiences. Moreover, the relationships between the issues are complex — between war and domestic violence, between movements for peace and movements for justice, between nationalism and women's rights. Women's analyses of the system and their visions for the future differ. Some argue for more women in positions of political power; others advocate grassroots activism. Some focus on increasing women's participation in the system; others want to reject or transform that system. Generalizations over time, class and culture are impossible. The differences are too great. Yet sometimes the connections pop up in the most unexpected places.

Are women more peaceful than men?

There is, perhaps, no *woman*, whether she have borne children, or be merely a potential child-bearer, who could look down on a battlefield covered with the slain, but the thought would rise in her, "So many

mothers' sons! So many bodies brought into the world to lie there! So many months of weariness and pain while bones and muscles were shaped within...; so many baby mouths drawing life at woman's breasts — all this that men might lie with glazed eyeballs and swollen bodies, and fixed, blue unclosed mouths and great limbs tossed — this, that an acre of ground might be manured with human flesh!".[2]

In all societies, it is women who give birth and nurse babies. In most societies, women are the primary care-givers responsible for the children and for the family. The role of women in nurturing, building relationships and maintaining the family is central to their identity. This concern with relationships and people often means that women play the role of peacemakers within their families and their communities.

Carol Gilligan has shown that women perceive the world differently from men, that they see the world as a web of relationships in which individuals can be identified by their relationships with others.[3] Their concerns with relationships are the basis of their nurturing role, their passion for affirming life, their opposition to war. She finds that men tend to have what she calls an "ethic of justice" which proceeds from the premise of equality — that everyone should be treated the same. Women, on the other hand, are more likely to have an "ethic of care", which rests on the premise of non-violence — that no one should be hurt.

In most societies these values are transmitted to boys and girls from an early age. Girls are reared to be docile, obedient and nice. In many places, they are brought up to believe that their role is to serve men, to sacrifice their own needs for the good of the man, for the well-being of the family. Their gods are male gods, often gods who glorify war and domination. It was not always this way. Women's myths and rituals, which often predate Christianity and Islam, affirm the power of women to give life and hint of societies in which women and their values are central.

Traditionally, women are seen as closer to the life-giving earth, associated with fertility and cycles. Women as nature, as sexuality, as fertility are mythic images deeply embedded in our cultural psyches. This concern with the earth, this reverence for life is manifest in many forms: from ancient goddess symbols of fertility to the fascination of women today with the deep ecology movement. Women's holistic visions of the world integrate a concern for the environment, for creation, with a reverence for life — all life — in community.

In contrast, wars are started by men operating in male systems. Hilkka Pietila says that "the idea of killing another human being is extremely alien to women". Aggressors have always been men. There is not one case in which women have set out to conquer. While women are occasionally violent, women have never institutionalized violence.[4] Betty Reardon summarizes the relationship between militarism and patriarchy, which has been extensively studied by feminist researchers: "Authoritarian patriarchy, which seems to have emerged with the major elements of 'civilization' — human settlements, organized agriculture, the state and male domination — invented and maintains war to hold in place the social order it spawned."[5]

Modern survey data in Western countries show a consistent pattern of women providing less support than men to militaristic policies, to wars (in general and particular) and to capital punishment. The surveys show patterns of women's preferences for environmental protection, for social policies of education and health, for peace initiatives. For a variety of reasons women are more likely to advocate peace and to oppose wars than are men. As we shall see, this assumption has formed the basis of the women's peace movement and provided the motivation for thousands of women's groups working to change the societies in which they live. It has led to major political movements, alternative forms of social organization and women taking the "moral high ground" in debates over political issues and in interpersonal relations.

But if women are so loving, peaceful and nurturing, why do so many of their sons become violent? Women are often the transmitters of culture within the family; and some of the values they transmit are precisely the values which lead not just to war but to the glorification of it. Think of the mighty war machines of this century — Nazi Germany, imperial Japan, militaristic US — or the battles for the Falklands/Malvinas or the Iran-Iraq war. In all of these cases, mothers often willingly sacrificed their sons for the war effort. With variations over time and place, women have always been a necessary part of the war machine in mobilizing support and providing the bodies to do the fighting. Even though there has been a vital women's peace movement for generations, and even though women tend to be less supportive of wars than men, they still support them in large numbers. Most wars have been fought with their acquiescence and support.

Nationalism is undoubtedly one of the major reasons for war. Wars have been fought between nation-states in pursuit of national security and national glory. Wars have been fought — and are increasingly being fought today — to affirm ethnic and national values. Struggles for self-determination, for indigenous rights, for ethnic autonomy have many features that affirm life and enhance community. But they often imply a denigration of the other, a hatred of other ethnic groups that leads to violence, war and sometimes unspeakable atrocities. Women's roles in building and creating nationalism have not been systematically studied, but can be assumed to be central. The mother in the USA who teaches her children that "the United States is Number One", the Croatian mother who depicts all Serbs as enemies, the Palestinian mother who nurtures her hatred for Israelis alongside her desire for the homeland, the Armenian mother who keeps alive the aspirations and memories of her people — all are fostering nationalism, with all its implications, both positive and potentially militaristic. As products of the societies in which they are reared, women not surprisingly share many of the same values as those societies.

Although women tend to be more "peace-loving" than men, there have always been violent women. Joan of Arc was glorified for her military prowess. Rani Lakshimi Bai of Jhansi, a warrior in the great Maratha tradition, led her troops against the British in India. French women were incredibly violent towards Nazi collaborators after the second world war. In some Native American traditions, women were responsible for the torture and mutilation of prisoners. Women have played important military roles in armed struggles for national liberation. Women's desires for revenge, for punishment, for blood are strong — and do not fit the myth of women as peace-loving nurturing mothers. Compared with male violence, female violence may be more unstructured and anarchic, but the potential for violence is still present, though perhaps in a different form from that within men.

In exploring the connections between patriarchy and women's oppression, some writers have pointed out how women collaborate in this pattern. According to Cynthia Adcock,

> Militarism is primarily a male phenomenon and the ultimate power of patriarchy is the organized, legitimized violence of the nation-state. For millennia, part of women's role has been to decry male aggression. We often see ourselves as posing a better way — a more loving, nurturing way of life than the masculine mode poses. Sometimes love and hatred

seem polarized along sex lines... We have generally portrayed ourselves as the victims of male domination, downplaying the areas in which we ourselves hold power. We have thoroughly described and documented that half of the age-old saga of domination and oppression in which we are the victims. We have not yet fully recognized the effects of maternal power over children as a root cause of resentment, fear and hatred of females. Rarely do we admit that males have sometimes been our victims, as we have been theirs. [6]

In the dichotomy frequently assumed between peace-loving women and war-mongering men, men are often seen as victims. Indeed, much of the feminist movement has affirmed that men, trapped by tradition into playing certain roles, unable to express feelings, shackled into a macho role, have also been victimized by patriarchal structures. Militarism makes this victimization even clearer. It is usually men who are sent off to war to do the fighting and men who die on the battlefields. The fact that men are more likely than women to do the fighting is usually ascribed to their greater physical strength and to cultural beliefs that warfare is appropriate male behaviour.

The movement for women's rights is also influencing traditional understandings of women as inherently more peaceful than men. Women's rights advocates in some industrialized countries, for example, argue that women have a right to fight in the armed forces, to assume more active roles in combat. Some even assert that having more women in the military will change and humanize the military itself. But the weight of the evidence goes in the opposite direction: when women participate in the military, they are the ones who are changed, not the military. In other contexts, women mobilize to support nationalist struggles not only in order to affirm their culture but also to increase their relative power in society. But "throughout the world, men have seen in the state and in the ideologies legitimating it — of which nationalism is the most potent — a means of enforcing their control over women". Nationalism is not gender-neutral; it seeks to mobilize women for a particular purpose. [7]

If women's nurturing, peace-loving, life-affirming role is to be strengthened, if it is to have the power to transform the world, then we need to look more deeply into that role and the sometimes disturbing contradictory forces within it.

As long as we ascribe to our oppressor what we can't control, we also remain helpless to change it. It is far more frightening to look into

ourselves to see how we have collaborated in allowing the death culture to take over than to place the blame entirely outside ourselves. Yet ultimately it is perhaps also our only hope, for if there are forces within women, as well as within men, leading to violence and violation of our human potential, we as women can play a very big part in turning the course of events, by trying to probe and understand and act on what we are beginning to find out. [8]

The conclusion from this brief survey of some of the literature seems to be that women are more peace-loving than men, but that they play a role in maintaining the war system and in transmitting cultural values that make wars more likely, and can themselves sometimes be quite violent. Elise Boulding says:

> I don't think women are naturally more peaceful than men. They have to learn to be peaceful, just like men do, but women are in situations where they develop their peaceable capabilities, such as child-rearing. You have a chance to learn things when you work with children. Men who are removed from that process of human growth don't get the same chance to cultivate that peaceable nature. It's not inherent. [9]

While the question of whether women are "inherently" more peaceful than men is interesting, the fact remains that nearly all of the world's wars have been initiated and largely fought by men. Even while women can be very violent and often support violence through their social roles, the war *system* and the institutionalization of violence are primarily male constructions. While women may provide implicit support for government's war-making abilities and while their silence often implies acquiescence to decisions to initiate or prolong conflicts, it is men who make the actual decisions to go to war, to conduct a war in a certain way and to stop fighting. But women are among those most affected by decisions to go to war.

Women and wars
There seems to be a trend towards greater participation of women in the armed forces. In a host of revolutionary situations — Nicaragua, El Salvador, Angola, Namibia, Eritrea, to mention a few — women have played leadership roles. In non-revolutionary situations, women's military participation has been largely limited to industrialized countries. The Gulf war in 1991 narrowed the gap between the duties of men and women in the US. While women were excluded from "combat positions", they were allowed to launch Patriot miss-

iles. As military intervention becomes increasingly technological, it is likely that women will play ever more active military roles. The deployment of 20,000 US women to the Gulf also changed the perception of the role of women in combat — as well as patterns of child-care in the US (largely assumed by grandmothers for children whose mothers were off fighting). The war also changed patterns of combat within Israel: when Iraqi missiles were launched against the country, Israeli males for the first time did not fight but sat with their women and children in sealed rooms. Meanwhile the war and the presence of foreign troops, including women, in Saudi Arabia and Kuwait led women there to question their own social roles. [10]

Despite these recent trends, the most prominent form of women's participation in war remains as victims. Awareness is growing that violence against women in armed conflicts is often a conscious policy, not an incidental by-product. Rape and sexual intimidation are common features of war in all societies. As Susan Brownmiller argues, rape and war go hand in hand. [11] The hundreds of thousands of rape victims in Bangladesh, in China during the Japanese invasion and in Cyprus were not side-effects of the war, but part of a deliberate policy to demoralize and humiliate the enemy. The widespread and sometimes systematic rape of women in the conflicts engulfing the former Yugoslavia has been the most recent manifestation of a long-standing phenomenon. What was unusual in this case is the amount of media attention it received and the subsequent emergence of a movement to include rape as a war crime under international law.

Increasingly, the victims of war are civilians. In the first world war, some 5 percent of casualties were civilians; by the second world war, estimates are that this increased to 50 or even 75 percent. Casualties in contemporary wars are over 90 percent civilians. In other words, women are as likely as men to be victims in conventional warfare today.

Among the world's 17 million refugees more than half are children under 16; among the adults, women make up a majority. Although systematic data about conflict situations that produce refugees are lacking, it appears that men are more likely to stay behind to fight, to send women to safety or to be killed. But for refugee women, escape from the immediate fighting often does not mean escape from violence. They commonly suffer harassment, intimidation and rape during their flight, at borders and in refugee camps. The breakdown of social norms and mores as a result of the uprooting may foster a

climate of violence within refugee camps. A survey by non-governmental organizations has shown that the greatest threat to women living in refugee camps comes from domestic and community violence. While a war that displaces women from their homes is usually considered a matter of international politics, the violence women experience in refugee camps is typically dismissed as marginal to international affairs. Yet that violence is affected by international policy decisions, such as the budgeting and programming policies of the United Nations High Commissioner for Refugees.

In other situations where governments are repressive and human rights violations widespread, women are also victims. They are imprisoned, tortured and killed for their political activities — or simply to intimidate their male relatives or colleagues. Thus, a woman might be abducted in order to pressure her husband or father or brother or son to turn himself in. Sometimes women suffer human rights abuses because they reject social mores regarding their proper role; for example, some women have fled Iran because of reprisals for refusing to wear the veil or to abandon certain professional occupations.

Women's suffering from violence against their family members and communities has been one of the main motivating forces for women's organizations. While both mothers and fathers grieve over an imprisoned child or a disappeared spouse, in cultures where a woman derives her identity from her role within the family, such a loss may be deeper for a woman than for a man, for she has lost not only a loved one but also part of her reason for being.

Women suffer disproportionately from the effects of militarized economies in which governments choose to devote scarce resources to arms and wars. When a government shifts money from education to military spending, more women than men lose teaching jobs, while more men than women gain jobs in the military sector. The relationship between military spending and foreign debt has been well-documented; and it is women and children who suffer the most from the economic and social consequences of this.

Wars have other consequences for women. There is considerable evidence that men who return from wars are more likely to be violent towards their wives. [12] As one author writes, "militarism and violence against women are inextricably linked. Military spending not only creates an economic injustice for women, it supports the ethic of violence against women." [13]

Violence beyond wars

> If a person is murdered because of his or her politics, the world justifiably responds with outrage. But if a person is beaten or allowed to die because she is female, the world dismisses it as "cultural tradition". [14]

We noted above that wars between or within countries are traditionally considered issues of international politics while violence against women in the family or community is seen as an issue in the "private sphere". But women are rejecting that distinction, as we shall see, with far-reaching consequences. In both cases, violence against women is widespread and related to patriarchal structures. In some cultures, beating of wives and children is an accepted tradition. In other cultures, violence against women and children is becoming more prevalent as a result of the breakdown of social mores, increasing urbanization and frustrations resulting from unemployment, alcoholism and drugs.

In most cultures violence against women is not openly discussed or acknowledged. Rather it is kept undercover by a tradition that "a man's home is his castle" and what he does there is of concern only to him and his family, not to the community. After a law reform committee in Papua New Guinea reported that 67 percent of rural women and 56 percent of urban women were victims of wife abuse, parliament debated whether wife-beating should be made illegal. Most ministers were vigorously opposed, on the ground that the government should not interfere in family life; as one of them argued, wife-beating "is an accepted custom... We are wasting our time debating the issue." [15] In the United States in the 19th century, Susan B. Anthony is said to have encountered far more resistance among Quakers for sheltering a woman battered by her husband than for housing escaped slaves. [16] When cases of family violence come before the courts, "almost universally, the social impulse is to preserve the family at all costs even if this compromises a woman's safety. As a male high court judge in Uganda said, 'It is better for one person to suffer rather than risk a complete breakdown of family life.'" [17]

The alarming statistics of violence against women are virtually universal. In Peru, 70 percent of all crimes reported to the police are of women being beaten by their partners. A study in the largest slum of Bangkok found that 50 percent of married women are beaten regularly. In Austria 54 percent of all murders in 1985 were committed in the family, with women and children constituting 90 percent of the victims. Dowry deaths in India and Bangladesh number in the

thousands; and as women advocates there point out, bride-burning is only the most visible and sensational symbol of a continuum of violence. One in four US women can expect to be the victim of domestic violence during her lifetime. [18]

Explanations abound of the reasons for the persistence of violence against women within the family. But as Sanna Naidoo from South Africa has said, "Some people say that unemployment, alcohol, *dagga* [marijuana] and overcrowded housing causes men to beat women. Things like *shebeen* [local bars] and poverty do make things worse. But they are not the root cause of the problem. Men get away with beating their wives and girl-friends because they believe that it is men's right to own and control women." [19]

One of the characteristics of the present-day women's peace movement is to identify the connections between domestic violence and war, between economic oppression and militarism, between women's rights and environmental concerns. We turn now to an examination of the ways in which women are working for peace.

Women and peace

> To focus on rage alone will exhaust our strength, forge our energy into a tool of the patriarchy's death-lure, force us to concede allegiance to the path of violence and destruction. On the other hand, compassion without rage renders us impotent, seduces us into watered-down humanism, stifles our good energy. Without rage we settle for slow change, feel thankful for titbits of autonomy tossed our way, ask for something mediocre like "equality". It is with our rage we defy the male supremacies, find the courage to risk resistance. And it is with our intimate connection to the life-force which pulses through our veins that we insist there is another way to be. By combining our rage with compassion, we live the revolution every day. [20]

Since the beginnings of recorded history, women have been working for peace — and picking up the pieces from the wars started by men. As Elise Boulding says,

> the basic energies common to all human beings have been redirected so that men seek power and women protect men from the consequence of power-seeking... At the close of every war, destroyed communities have been rebuilt, and much of the physical labour of rebuilding has been women's work. Another activity traditionally expected of women is conflict resolution, since it is troublesome to go to war all the time. The old practice of marrying the daughters of one village to the sons of the next was a war-avoidance strategy. [21]

The modern Western women's peace movement is usually dated from the middle of the 19th century. At that time a number of social movements seemed to come together: movements to abolish slavery, movements for women's rights, labour unions, temperance societies and movements promoting non-violence. The Philadelphia Female Anti-Slavery Society, founded in 1833, was the first active political organization for women in the United States. The movement for women's suffrage which grew throughout the 19th and early 20th centuries often linked a concern for peace with a commitment to women's rights; and some of the early suffragette literature reflects the confidence of many that wars would end once women had the vote: "When women get the vote, it's a sign that that country is ripe for permanent peace." [22]

Women in Europe and North America organized in an effort to prevent the outbreak of the first world war. In July 1914, the International Women's Suffrage Alliance presented a petition for peace to the British foreign ministry signed on behalf of 12 million women in 26 countries. Once war broke out, the suffrage movement divided between those who supported their government's war efforts and those who continued to work for peace. The International Congress of Women at the Hague in April 1915, presided over by Jane Addams, brought together over a thousand women and agreed to send envoys to the European and US governments in a plea to stop the war. Although that effort did not succeed, the congress did create a basis for the women's peace movement. The Women's International League for Peace and Freedom was born out of the Hague Conference; and the Women's Peace Crusade, formed in 1917-18, brought in grassroots movements. All these groups faced tremendous resistance in their own societies as they sought to mobilize anti-war sentiment.

Shortly after the war, in 1923, the War Resisters League was founded by three women: Jesse Wallace Hughan, Tracy Mygatt and Frances Witherspoon. Jeanette Rankin, a steadfast worker for peace, was the only member of the US Congress to vote against her country's participation in both world wars. Women's groups mobilized against the second world war, and women's peace movements sprang up in its aftermath to combat the cold war mentality. In the United States, Women Strike for Peace, formed in 1961 to protest the arms race, endured harassment and intimidation. Scandinavian Women for Peace brought half a million signatures to

the United Nations secretary general at the world conference of the International Women's Decade in Copenhagen in 1980; they discovered that German women had also brought 100,000 signatures. At Greenham Common and the Pentagon, women's actions for peace mobilized thousands of women to protest policies making nuclear war more likely.

In thousands of other communities, women have not only opposed war but organized to resist the invasion of their countries. Vietnamese women have played a vital role in the struggles of their country for centuries, beginning with the national uprising led by the two sisters Trung in A.D. 39 against the aggression of the feudal An dynasty from the north. Me Katilili, a 70-year-old Giriama woman in Kenya, organized her people against the British in the uprising of 1911-1914. Campaigning from settlement to settlement, she incited the Giriami with her fiery speeches and built solidarity among them. They pledged to refuse to pay taxes and do forced labour, and to keep colonial settlers from their lands. When the resistance fighters set several administration offices on fire, the British arrested and imprisoned Me Katilili.

After generations of silence, women's stories of their struggles for social change and for peace are beginning to be told. There are thousands of stories — of women in Northern Ireland protesting violence, of Palestinian and Israeli women trying to overcome barriers of distrust and enmity, of the Mothers of the Plaza de Mayo in Argentina, of Japanese women protesting racism and nuclearism, of South African women whose long history of nonviolent resistance has been central to that country's struggle, of Nigerian women taking over the marketplace, to mention only a few. Some of these stories are recounted in this volume. Story-telling is both a subversive activity and a sustaining one. As Pam McAllister explains, by telling the stories of resistance and action, "the courage that has come before is not lost but flows like a river, cutting through history's bleakest terrains and most barren deserts, its waters feeding us still, sustaining life through our valleys of despair". [23]

Many of these stories tell of women being motivated to act because they are mothers, agonizing over their children's disappearances, angry because of continuing violence which destroys their families. Maternal thinking is indeed a powerful motivation for women's action for peace and justice, though as we shall see it is not the only one.

Maternal thinking

Both activists and academics have explored the extent to which women's political activism and commitment to peace results from their experiences as mothers. One of the most influential authors in this field is Sara Ruddick. She begins by looking at the implications of being a "mother", of caring for children as a regular and substantial part of one's working life, and finds that mothers acquire a fundamental attitude towards the vulnerable, a protectiveness which she calls "holding":

> To hold means to minimize risk and to reconcile differences rather than to sharply accentuate them. Holding is a way of seeing with an eye towards maintaining the minimum harmony, material resources and skills necessary for sustaining a child in safety. [24]

Maternal thinking is reinforced by women's work in "caring labour" of "sheltering, nursing, feeding, kin work, teaching the very young, tending the frail elderly". [25] Maternal roles of resolving conflicts within families, reconciling differences and naming threats to their children create a certain predisposition towards working for peace and using nonviolence.

But being a mother is not enough to lead to peace; like men, women are often caught up in the pressures of conflict and the excitement of war. The relationship between maternal roles and peace is not so simple.

> A pure maternal peacefulness does not exist; what does exist is far more complicated: a deep unease with military endeavours not easily disentangled from patriotic and maternal impulses to applaud, connect, and heal; a history of caring labour interwoven with the romance of violence and the parochial self-righteousness on which militarism depends. [26]

This unease with militarism coupled with women's history of caring intervention not only creates a predisposition to resist violence, but also justifies action. Maternal protectiveness is continually expanding its domain of action. A mother's concern to keep her home safe expands to working for a safe community or to opposing governments which threaten that security.

Motherhood is a powerful motivation for political action in all parts of the world. The Mothers of the Plaza de Mayo in Argentina were acting as mothers — and not as political activists — when they began to protest the lack of information about their disappeared children.

No mother is asked what her ideology is or what she does; neither do we ask what her children were doing. We do not defend ideologies; we defend life... Our great concern is not to be manipulated by any political party... Neither the government's threats nor their rifles are a match for the faith of a mother.[27]

In repressive situations, when women act because they are mothers, authoritarian governments often do not know how to react. During the military dictatorship in Uruguay, women's groups could continue to act even when political groups were forbidden, since they were acting because of their roles within the family.

There was nothing feminist in their formulation; motherhood and house-wifery propelled them to act... The military ideology, with its paternalis-tic overtones, could not find fault with what Uruguayan women were doing, because women were doing what they were supposed to do according to the military definition of gender roles: they were acting as mothers, wives and housewives.[28]

Similarly Palestinian women's involvement in the struggle for self-determination is shaped by their role within the family. Palesti-nian women's groups do not use Western arguments that women should not be regarded only as wives and mothers but rather insist that they should be respected *because* they are wives and mothers respon-sible for the upbringing of Palestinian children.[29]

But when women act as mothers, even without political conscious-ness, they play a role in transforming society. Maria del Carmen Feijoo argues that the Mothers of the Plaza de Mayo became in practice "another movement of women who, without trying to change patriarchal ideology or abandon their femininity, produced a transfor-mation of the traditional feminine conscience and its political role. As a result, a practical redefinition of the content of the private and public realms has emerged."[30]

But maternal thinking and maternal roles do not necessarily lead to defiant action against oppressive governments. "When women mobilize as mothers on behalf of their families, they become a potent political force, but one as adaptable to repressive as to liberating causes."[31] Governments from Hitler's Germany to Pinochet's Chile have mobilized women to support their regimes by appeals to "defense of the family". Thus some feminists are critical of building a peace movement on women's identity as mothers. Women play many roles in society and justifications based on biology reinforce patriarchy.

They also suggest that linking maternal values to peace-making absolves men of their equal responsibility to value and protect life.[32]

Of course, women are motivated to work for peace and justice for many reasons. Sometimes they are moved to action because governmental policies threaten their place in the family and society. As early as 1913, Indian women in South Africa organized when the government said that only Christian marriages were legal. In Iran, women's groups organized for the right not to wear the veil; in some cases their protests led to their deaths. Sometimes women see their actions as motivated by forces larger than their own self-interest. Maggie Lowry explains her presence at Greenham Common: "I am not here just because I don't want my children to grow up threatened with a nuclear holocaust, nor for the opportunity of sheltering from the flagrant sexism I used to confront in the streets of a busy city. I am here because my heart weeps over the great folly of men planning for war throughout the ages."[33]

Yet despite the possible dangers of emphasizing women's biological roles and overlooking the many other factors that motivate women to become active, it is evident that women's political actions are often the result of maternal thinking.

Organizing for peace and change

One of the problems in analyzing women's political actions is the way in which the term "political" has usually been defined. For example, women's activities in community or church groups are often labelled as "volunteer" or "charitable" or "social" even though they have a political impact. As Brookman and Morgan conclude, "until we broaden our definition of politics to include the everyday struggle to survive and to change power relations in our society... women's political action will remain obscured".[34]

In their study of women in social protest movements, Guida West and Rhoda Lois Blumberg suggest four types of issues around which women organize:

1. economic survival (obtaining food, jobs, welfare);
2. nationalist or racial/ethnic issues (including both right-wing and progressive issues);
3. humanistic and nurturing issues, such as peace, environment, public education, mental health care;
4. women's rights.[35]

The third category is most closely related to the "maternal thinking" by which women have historically justified their political involvement as an extension of their nurturing work at home.

Of course, there is considerable overlap between these categories; and involvement in one type of social movement leads many women to see the connections and become involved in others. Sometimes women organize in women's groups because they feel that there is no place for them within existing action groups. Many women have stopped working within progressive social movements and struggles for national liberation because of the sexism. As one Israeli woman activist says, "Peace Now leadership is definitely chauvinist... They are getting better, but they have no awareness that women have something to say and want to be addressed equally. Yes, there are women there, but did you see any of them on television? Did you know about them?"[36] There are also cases where women's peace initiatives have been disdained by men's groups until they become successful — at which time the male-dominated groups try to co-opt them.[37] Comparing women's involvement in gender-integrated and gender-separated movements, West and Blumberg found what they call "the iron law of patriarchy": in groups of women and men working together on issues, even progressive issues, the result is male domination.[38]

Sometimes, changes in the social context appear to encourage women's participation in protest activities. For example, under the military dictatorship in Brazil there was a dramatic expansion of women in higher education, while an increasingly active Catholic Church led women militants to work in poor areas. The return of women exiles to South America following the transition from military rule was another force encouraging women to take a more activist role.[39]

While generalizations are impossible, there are some suggestions of ways in which women's work for peace differs from others. Birgit Brock-Utne identifies three characteristics of women's work for peace:

1. It is connected to the concern for human life, especially for children, but also for themselves and other women.
2. It makes use of a varied set of nonviolent techniques, acts and strategies.
3. It is transpolitical, often transnational, and is aimed at reaching other women in the opposite camp.

While the rich variety of nonviolent techniques used by women has been amply demonstrated in stories told by individual women throughout the ages, much of women's peace work remains invisible. Except for the occasional large demonstration, the activities of women's peace groups are usually unreported by the mass media. When they are reported, they are often trivialized. The process of recovering women's experiences of resistance and nonviolent action is just beginning.

There is much we do not know about how women organize for peace and justice. Research on the internal structures of women's groups is scanty, although there is some evidence that women's groups tend to be less hierarchical and more concerned with networking than with developing a "territorial" sense of a power base. In general, it appears that women's groups are less concerned with structures — with formal membership, constitutions and leadership — than other groups. The friendship and solidarity which women experience in these groups may be as important as the political causes they espouse. Studies of Peruvian women participating in communal kitchens and volunteer feeding programmes show that while these arose as an economic survival strategy, the women stayed in these groups because of the solidarity and friendship they felt with other women in the group. [40] Women tend to organize around a specific cause or grievance, from their disappeared children to disappearing forests. Often in the course of their work on a particular issue, they come to see the larger connections and move into new, often more political areas of work.

Women at Greenham Common report that the link between small affinity groups and the international movement was a source of strength and creativity. The former encouraged direct actions which no central organizational structure could have imagined or planned, "but instead of being an isolated enclave, the affinity group is linked to others in an international network, which shares some if not all of the small group's goals". [41]

De-emphasizing formal structures may create problems. Women's groups may avoid conflict and may have ambiguous feelings about leadership, oscillating between being anti-leadership and responding to charismatic leaders. [42] According to Mallica Vajrathon, it is difficult for Thai women to organize and take action as a group

> because we are influenced by Buddhism, which taught each of us to be self-reliant and to look after herself as an individual. The other difficulty

we face is that to date most Thai women prefer negotiations to manipulate the weakness of male opposition to our advantage, rather than to engage in confrontation with the male establishment and structure, whose sexist attitudes will take a long time to change. [43]

Similar things could be said of women in many other cultures who prefer to avoid confrontation and conflict.

In a study of the Working Women's Forum in Madras, India, a researcher reports that in her initial interviews "a word was ringing in my ears. It was not a word I expected, like 'power', 'empowerment', 'leadership', or 'good or bad leaders'. It was '*dhairiyam*', i.e., courageous, brave or bold." [44] She came to see this "boldness" as a defining characteristic of women's grassroots movements.

> Truly, grassroots leadership is about boldness: the boldness to face one's life and one's community; to bring to consciousness inner contradictions and conflicting values; to challenge the fear of injustice and oppression; to overcome cowardice in oneself and others; and to walk away from stale and stifling traditions. It is about the courage to change and to be, that is, to step out of a well-trod rut to start on a new and unknown path. [45]

This boldness is apparent in the stories of women activists working in war-torn countries. It requires courage to confront police or a dictatorial government; and women's actions for peace and justice often exhibit a creative boldness that almost mocks the forces of oppression. When the Mothers of the Plaza de Mayo gathered in the main square of Buenos Aires to protest their children's disappearances, they used symbols and photographs to move beyond protest to confront the powers of the government. For the Green Belt movement in Kenya, the simple act of planting trees has acquired a political momentum of boldness. In other situations, where the degree of personal risk is less, women have shown great creativity in confronting the war machine. For example, at Greenham Common and the Women's Pentagon Action, women activists have creatively dramatized the threat posed by expanding nuclear arsenals.

Perhaps the greatest contribution of organized women's groups for justice and peace is the emphasis on networks which emerge out of sharing stories and seeing common bonds. Concepts of national security and national defense seem to have a different meaning for women. Examples abound of women reaching out to women on the other side in an effort to find common bonds. International solidarity has been expressed in a variety of ways between women's groups struggling in different ways on different issues. Sometimes these

international connections can provide protection for women who are in danger because of their activities.

The fact that women organize around different issues may lead to tension between women's groups, particularly between Northern and Southern women who have different priorities. While Western white women have been at the forefront of efforts to dismantle nuclear arsenals, "from the point of view of women of colour, who are the majority of the majority of the world's people, and who are also the poorest, the threat of nuclear war and nuclear power is inseparable from day-to-day military-industrial repression: 'sex', 'race' and 'class' issues are 'peace' issues."[46] Women's struggles today encompass the full range of peace, justice and environmental issues: from racism to nuclear dumping, from wife abuse to the policies of the International Monetary Fund, from military spending to sexual harassment. Often, as we have seen, when women organize around a specific issue, such as providing food to a shantytown, they come to see the connections and move beyond the group's original purpose.

At the same time, it is important to acknowledge that women often organize or are organized in support of the status quo. Not all women's groups espouse progressive agendas. While some Chilean women's groups have organized for democracy and for life, Ximena Bunster notes that the network of women's organizations created to support the military dictatorship of General Pinochet evolved to encompass an estimated 2 million women in the ten years between 1973 and 1983. This mobilization of political support from women was crucial to Pinochet's remaining in power.[47]

Little is known about what happens to women's groups in the long run. There is some evidence that those which emerge to meet a specific situation simply fade away once that situation changes. Argentine women who mobilized in opposition to the dictatorship and for human rights were effective advocates of change, but after the transition to democracy they became less visible, leading one observer to suggest that in general "women mobilize to meet the demands of a crisis, but this mobilization is fragile, and women often return home when the crisis is past".[48] Moreover, the skills that are effective in mobilizing women to protest and denounce are not as effective in working within traditional political structures. Political know-how and negotiating tactics are essential. Similarly in Uruguay the women's groups that were active during the military dictatorship were limited in scope and life-span. They could not (or would not) move towards

solidifying their organizational base and remained loosely structured with fluctuating membership and a reluctance to plan beyond the immediate situation. "The groups were formed to solve particular problems without any reference to the global context"; and once that problem disappeared, the group dissolved. [49]

Women and nonviolence

There are of course cases in which women have used violence in defense of their goals. But much more common has been their commitment to nonviolence, exercised in countless creative ways and largely ignored in the standard works on nonviolence.

Nonviolence means different things to different people. To some it is synonymous with passivity, turning the other cheek, being less militant than those who use violence. To others it is one of many "tactics" to use as appropriate in the struggle. To still others it is a way of life grounded in a spiritual basis.

Although nonviolence has a long history and has been shaped by the words and actions of many people, it is most often associated with Mahatma Gandhi, who saw the essence of nonviolence as *satyagraha* or the life-force of truth. His commitment to nonviolence was much more than a tactic; and far from being a sign of weakness, it was to be used by the powerful, those who had the truth on their side. In actions and writings over thirty years, Gandhi demonstrated the power of nonviolence not only to bring about political change but to transform the lives of its adherents.

Gandhi attributed much of his learning about nonviolence to the movement for women's suffrage in England. But nonviolent women revolutionaries emerged as leaders of the independence movement in India long before Gandhi. Elise Boulding cites the ground-breaking work of Kristo and Kumudini Mitter, Swami Kumari and Sarla Devi and Madame Bhikaiji K.R. Cama.

> Teenage Kanak Lata Barua and the 73-year-old Manangini Harza, both shot by the British on separate independence marches in 1942 in India, stand for many women who provided the leadership which helped village women all over India take the courage to engage in civil disobedience against the salt tax and other indignities, face English gunfire unarmed and accept martyrdom in the hundreds, imprisonment in the thousands. [50]

More than 60 percent of the participants in the Salt March organized by Gandhi in March 1930 were women; and of the 30,000 people arrested, 17,000 were women. [51]

Gandhi has inspired both men and women to consider ways of using nonviolence in different situations. But women are perhaps more drawn than men to his teaching of a nonviolence grounded in love, truth and spirituality. Gandhi himself saw women as offering the best hope for the practice of nonviolence.

However, some feminists have questioned the applicability of Gandhian principles to the current women's struggles. Judy Costello suggests that men and women need to approach nonviolence differently. While Gandhi saw suffering and self-sacrifice as the essence of nonviolence, women have often been too self-sacrificing, too willing to make excuses for abusers, and perhaps need to work more on developing their self-love and self-acceptance. [52]

Other feminists, primarily in the West, have criticized any practice of nonviolence which does not include a commitment to women's issues:

> Any commitment to nonviolence which is real, which is authentic, must begin in the recognition of the forms and degrees of violence perpetuated by... men. Any analysis of violence, or any commitment to act against it, that does not begin there is hollow, meaningless — a sham which will have as its direct consequence the perpetuation of our servitude... Any male apostle of so-called nonviolence which is not committed, body and soul, to ending the violence against us is not trustworthy... He is someone to whom our lives are invisible. [53]

Nevertheless nonviolence continues to be used by women's groups. It may be, as Birgit Brock-Utne suggests, that in countries where women are associated with nonviolence, nonviolence itself is degraded. But events of the past few years have certainly shown the power of nonviolence to bring about political and social change. The transformation of Eastern Europe largely resulted from nonviolent action. In many situations it is difficult to separate the relative importance of the armed struggle from the larger nonviolent movements in bringing about change. For example, the success of guerrilla forces in holding government troops to a military stalemate was undoubtedly a major factor leading to a negotiated settlement in El Salvador, but the actions of thousands of Salvadoreans in nonviolent protests, strikes, demonstrations and other acts were also crucial. In all of these actions, women played an important role — a role which they continue to play in many countries.

But women have different priorities from men in their efforts to bring about change. One of the most apparent difficulties is that

between the struggle for women's rights and for other social and political change. For example, Karagwa Byanyima points out that Ugandan women in the early 1980s had no alternative for emancipation but to unite with men and fully participate in armed resistance during the guerrilla warfare.

> Ugandan women were not invited to take part in the national resistance war; they forced their way in. There was no women's movement in Uganda to encourage them, no leaders' speeches about women's emancipation, no consciousness-raising groups. The objectives of the struggle — human rights, democracy, nationalism — were clear and close to women's hearts.

And the new government insisted on women's participation by appointing women to nine of the 48 cabinet seats. [54]

Similarly during the war against the Somoza dictatorship in Nicaragua women made up 30 percent of the Sandinista Front for National Liberation. After the revolution both men and women felt that they had earned the right to participate in politics, and laws were passed offering support for women's issues. [55] Palestinian women likewise expect that because of their participation in the struggle, they will be included in the formal Palestinian government structures which emerge. [56]

Other experiences suggest that the link between women's rights and participation in struggles of national liberation is far from automatic. Marie-Aimée Helie-Lucas writes passionately about how women's fighting and suffering in the struggle for Algerian independence were devalued. After independence, they were disappointed; the time was never "right" for women's issues to be brought forward:

> We are made to feel that protesting in the name of women's interests and rights is not to be done *now*; it is never, has never been the right moment; not during the liberation struggle against colonialism, because all forces had to be mobilized against the principal enemy; not after independence, because all forces had to be mobilized to build up the devastated country; not now that racist, imperialist Western governments are attacking Islam and the Third World, and so on. Defending women's rights now — this "now" being *any* historical moment — is always a betrayal of the people, of the nation, of the revolution, of Islam, of national identity, of cultural roots and so on...
>
> Many of us, including myself, kept silent for a whole decade after independence, in order not to give ground to the enemies of the glorious Algerian revolution; by so doing, we only have given time to those in

power to strengthen and organize, allowing them, among many other things, to prepare and enforce discriminatory laws on women. Even now in Algeria, feminists try to analyze their oppression from within the Algerian context only, refusing to see the international side of it, for fear of being accused of betrayal. [57]

Women from other regions as well are seeing that positive political change does not always mean women will benefit. In the formerly socialist countries of Eastern Europe, political change has brought a decline in women's political participation. Under the old system, fixed quotas ensured that about one-third of the legislatures would be women; since the establishment of democratic governments women's participation has fallen to around 10 percent. Representatives of women's groups under the old system may have been "tokens", but at least they ensured "that there was a pressure group for implementing women's equality, however narrowly conceived, within the political structures of government". [58] As bureaucracies representing the extended arm of the state, official women's unions and leagues were, like many other organizations, discredited with the ending of communist rule. The new organizations which are emerging tend to be based in urban areas and to be more responsive to the concerns of university-educated women than the discredited organizations they replaced.

In Poland, women made up an estimated 50 percent of Solidarity's membership and played supportive roles throughout the struggle. Women saw their interests in the same terms as men. But while Solidarity criticized the communist regime, it did not challenge patriarchy or the power of the Roman Catholic Church. When round-table negotiations began in February 1989, women were omitted from any negotiating group. "The overall women's representation was pathetic. Women were not men's partners in the historical beginning of the collapse of the Communist regime." [59]

The political groupings which have subsequently come to power in these formerly socialist countries of Eastern Europe are overwhelmingly male. The discrediting of the former system seems also to have created a reaction against the progress made on women's issues during the communist years. Access to abortion and child care as well as social welfare policies are all threatened under the new regimes. In some cases, women themselves are organizing to have the right to stay home with the children instead of having to work outside the home. They are often ambivalent about their relations with Western femin-

ists, who do not understand the specific experiences women in the East went through. In the West, the feminist agenda has included making the personal political; such efforts are resisted by women's groups in the East, where the family was the only haven from the interference of the state. [60]

The question of the relationship between the struggle for women's rights and the struggle for social transformation is being enacted in different ways in different contexts, which is as it must be. While women can learn from the experiences of women in other parts of the world, their struggle must be shaped by their own experiences. There is no single model which is applicable to all groups.

And yet women's groups of all kinds are focusing on the connections between racism and sexism, between decisions made by international bureaucrats and poverty, between what happens in their families and communities and the rest of the world. As we have seen, one characteristic of women's groups working for peace and justice is a refusal to separate these issues from family issues. As the Forward-Looking Strategies adopted at the 1985 meeting on the UN Decade said, "The questions of women and peace and the meaning of peace for women cannot be separated from the broader question of relationships between women and men in all spheres of life and family" (para. 257). Increasingly, women are realizing that in order to change society, they must begin within the family and the community. "Women's capacity to challenge the men in their families, their communities or their political movements will be a key to remaking the world." [61]

* * *

Although researchers have collected women's stories and studied women's peacemaking strategies, many questions remain. What roles do women play in shaping their families' national, religious and ethnic identities? How do they resolve conflicts within their families and communities? What motivates individual women to become active on particular issues? Are there certain shared characteristics of women's groups which differentiate them from mixed groups? How effective are women's groups in stopping violence or changing the conditions which give rise to it? The more one learns about women's peacemaking efforts, the more questions arise.

The essays in this volume illustrate the many forms that women's actions take against the violence that confronts them. The issues and situations are just too different to warrant talking about a single women's approach to peace or a global women's peace movement. Rather, we see a rich variety of approaches and strategies, in which certain common themes emerge: a shared conviction to end violence which threatens life, an awareness of the interconnections between different forms of violence and an emphasis on practical action rather than grand theorizing. Women bring unique perspectives and gifts to the struggle for a world without violence.

NOTES

[1] This essay is adapted from the author's *Women, War and Peace*, Uppsala, Life & Peace Institute, 1993 (PO Box 297, S-75105 Uppsala, Sweden).

[2] Olive Schreiner, South Africa, 1911; cited in Daniela Gioseffi, ed., *Women on War: Essential Voices for the Nuclear Age*, New York and London, Touchstone Books, 1988, p.162.

[3] Carol Gilligan, *In a Different Voice: Psychological Theory and Women's Development*, Cambridge MA, Harvard U.P., 1982.

[4] Hilkka Pietila, "Women's Peace Movement as an Innovative Proponent of the Peace Movement as a Whole", *IFDP Dossier*, 43, 1984, p.12.

[5] Betty Reardon, *Sexism and the War System*, New York, Teachers College Press, 1985, p.12.

[6] Cynthia Adcock, "Fear of 'Other': The Common Root of Sexism and Militarism", in *Reweaving the Web of Life*, Philadelphia, New Society Publishers, 1982, pp.214,216.

[7] Fred Halliday, "Hidden from International Relations: Women and the International Arena", in R. Grant and K. Newland, eds, *Gender and International Relations*, London, Open University Press, 1991, p.164.

[8] Erika Duncan, "The Lure of the Death Culture", in *Reweaving the Web of Life*, p.221.

[9] Cited in Judith Porter Adams, *Peacework: Oral Histories of Women Peace Activists*, Boston, Twayne Publishers, 1991, p.188.

[10] Nira Yuval-Davis, "The Gendered Gulf War: Women's Citizenship and Modern Warfare", in H. Bresheeth and N. Yuval-Davis, eds., *The Gulf War and the New World Order*, London, Zed Books, 1991.

[11] Susan Brownmiller, *Against our Will*, New York, Bantam, 1975, p.114.

[12] One counsellor reports that about one-third of the US Vietnam veterans seeking counselling from his centre were involved in violence against women. Of the veterans who were married before going to Vietnam, almost 40 percent were divorced within six months of returning home. Cf. Rick Ritter, "Counselling Vets who Batter", in *Daring to Change: Perspectives on Feminism and Non-Violence*, New York, War Resisters League, 1985.

[13] "Militarism and Violence Against Women: The War at Home", in *ibid*.

[14] Lori Heise, "International Dimensions of Violence Against Women", *Response*, vol. 12, no. 1, 1989, p.3.

[15] *Ibid.*, p.5.

[16] Margaret Bishop, "Feminist Spirituality and Non-Violence", in *Reweaving the Web of Life*, pp.156ff.

[17] L. Heise, *loc. cit.*, p.4.

[18] *Ibid.*, pp.3-5.

[19] Cited by Heise, *ibid.*, p.6.

[20] Pam McAllister, in *Reweaving the Web of Life*, p.iv.

[21] Elise Boulding, "Warriors and Saints: Dilemmas in the History of Men, Women and War", in Eva Isaksson, ed., *Women and the Military System*, Hertfordshire, UK, Harvester/Wheatsheaf, 1988, pp.228ff.

[22] Jill Liddington, "The Women's Peace Crusade", in Dorothy Thompson, ed., *Over Our Dead Bodies: Women Against the Bomb*, London, Virago Press, 1983, p.187.

[23] *Loc. cit.*, p.8.

[24] Sara Ruddick, *Maternal Thinking: Towards a Politics of Peace*, New York, Ballantine Books, 1989, p.79.

[25] *Ibid.*, p.148.

[26] *Ibid.*, p.156.

[27] Cited by Jane S. Jaquette in Jaquette, ed., *The Women's Movement in Latin America: Feminism and the Transition to Democracy*, Boulder, Westview Press, 1991, p.188.

[28] Carina Perelli, "Putting Conservatism to Good Use: Women and Unorthodox Politics in Uruguay, from Breakdown to Transition", in *ibid.*, pp.107,110.

[29] Orayb Aref Najjar, "Between Nationalism and Feminism: The Palestinian Answer", in Jill M. Bystydzienski, ed., *Women Transforming Politics: Worldwide Strategies for Empowerment*, Bloomington, Indiana U.P., 1992.

[30] María del Carmen Feijóo, "The Challenge of Constructing Civilian Peace: Women and Democracy in Argentina", in Jaquette, *op. cit.*, p.77.

[31] Carolyn Strange, "Mothers on the March: Maternalism in Women's Protest for Peace in North America and Western Europe, 1900-1985", in Guida West and Rhoda Lois Blumberg, eds, *Women and Social Protest*, New York, Oxford U.P., 1990, p.209.

[32] *Ibid.*, p.218.

[33] Maggie Lowry, "A Voice from the Peace Camps", in Thompson, *op. cit.*, p.76.

[34] *Women and the Politics of Empowerment*, Philadelphia, Temple U.P., 1988, p.14.

[35] Guida West and Rhoda Lois Blumberg, "Reconstructing Social Protest from a Feminist Perspective", in *Women and Social Protest*, p.14. Jaquette (*op. cit.*, p.4) finds a different pattern of women's mobilization in Latin America, where three distinct groups of women's organizations emerged: human rights groups, feminist groups and organizations of urban poor women. Sara Ruddick (*op. cit.*, pp.222-34) distinguishes between women's politics of resistance and feminist politics.

[36] "Feminism and the State of Israel", *Peace Review*, vol. 2, no. 4, 1990, p.17.

[37] See the report on relations between No to Nuclear Arms and the Women's Peace March reported by Birgit Brock-Utne, *Educating for Peace*, New York, Pergamon Press, 1985, pp.67-69.

[38] *Op. cit.*, p.39.

[39] Sonia E. Alvarez, "Women's Movements and Gender Politics in the Brazilian Transition", in Jaquette, *op. cit.*, pp.18-71.

[40] Maruja Barrig, "The Difficult Equilibrium Between Bread and Roses: Women's Organizations and the Transition from Dictatorship to Democracy in Peru", in *ibid.*, p.138.

[41] Ann Snitow, "Holding the Line at Greenham Common: Being Joyously Political in Dangerous Times", in Gioseffi, *op. cit.*, p.352.

[42] Cf. Gay Young, "Hierarchy and Class in Women's Organizations: A Case from Northern Mexico", in *Women, International Development and Politics: The Bureaucratic Mire*, Philadelphia, Temple U.P., pp.79-97.

[43] Mallica Vajrathon, "We Superwomen Must Allow the Men to Grow Up", in Robin Morgan, ed., *Sisterhood is Global*, New York, Anchor Books, 1984, p.674.

[44] Claire L. Bangasser, "A Touch of Boldness: The Working Women's Forum, Madras, India: Women's Leadership in the Informal Sector", Webster University, M.A. thesis, 1991.

[45] *Ibid.*, p.5.

[46] Wilmette Brown, "Black Women Organizing", in *Daring to Change*.

[47] Ximena Bunster, "The Mobilization and Demobilization of Women in Militarized Chile", in Isaksson, *op. cit.*, pp.210ff.

[48] María del Carmen Feijóo, *loc. cit.*, p.72.

[49] Perelli, *loc. cit.*, p.107.

[50] Boulding, *loc. cit.*, p.232.

[51] Birgit Brock-Utne, *Educating for Peace*.

[52] Judy Costello, "Beyond Gandhi: An American Feminist's Approach to Non-Violence", in *Reweaving the Web of Life*, pp.175-80.

[53] Andrea Dworkin, "Redefining Nonviolence", cited in Pam McAllister, *op. cit.*, p.6.

[54] W. Karagwa Byanyima, "Women in Political Struggle in Uganda", in Bystydzienski, *op. cit.*, p.142.

[55] Barbara J. Seitz, "From Home to Street: Women and Revolution in Nicaragua", in *ibid.*, p.169.

[56] Najjar, in *ibid.*, p.157.

[57] Marie-Aimée Helie-Lucas, "The Role of Women During the Algerian Liberation Struggle and After", in Isaksson, *op. cit.*, pp.185,187.

[58] Barbara Einhorn, "Where Have All the Women Gone? Women and the Women's Movement in East Central Europe", *Feminist Review*, no. 39, 1991, p.17.

[59] Joanna Regulska, "Women and Power in Poland: Hopes or Reality", in Bystydzienski *op. cit.*, p.186.

[60] *Ibid.*, pp.31-34.

[61] Cynthia Enloe, *Bananas, Beaches & Bases: Making Feminist Sense of International Politics*, Berkeley, University of California Press, 1990, p.17.

2. *The Universality of Human Rights Discourse*

CORINNE KUMAR-D'SOUZA

Listen to the women
Listen
Listen to the women
They are arriving
Over the wise distances
On their dancing feet
Make way for the women
Listen to them.

Women no longer search for a space to be heard, they are slowly creating new spaces; they no longer plead for the right to speak, they are speaking; they no longer walk the beaten path, for they are now beginning to see that it is the forest and not the line that is their heritage. Women have begun to determine a new terrain where women's experiences are no longer denied, where woman's knowledge gives strength to the dailiness of her struggle for survival, where woman, listening to the earth, infuses magical colours into the *razai* in which she weaves worlds of meanings, creating new motifs, new metaphors, keeping children warm, making the depths of old wisdoms visible.

Listen to the women
Listen to the many voices
spoken and unspoken.

Women have been excluded from the main human rights discourse; from its precepts, from its praxis. The parameters that have defined the discourse have been drawn blinded to and mindless of

gender. Political paradigms that determine political thinking and institutions in our times have been based on the legitimated discrimination and degradation of women. These political paradigms have excluded and erased women. If we must look for a new understanding of human rights, then we must look anew, "with new eyes", as the Asian Women's Human Rights Council said in its statement to the world conference on human rights in Vienna in 1993:

> Women have begun to see with new eyes. We have begun to shift the parameters of the human discourse: we have dared to call rape a war crime. We have dared to call the battering, the burning, the brutalization of women as acts of female sexual slavery. We know today that most refugees are women, that women are the poorest of the poor, that poverty has a woman's face.

The old categories and concepts have become insufficient; they are almost unable to grasp the violence of the times. While we need to extend the horizons and to deepen the existing human rights terrain, we also need a new generation of women's human rights. We need to urge the passing of a paradigm that has understood human rights as the rights of the privileged and powerful. We need to listen to the voices of those who do not share that power, to see these violations through the eyes of the victims of development, of progress, of technical fixes, through the eyes of the powerlessness of those on the edges — the indigenous, the tribals, the dalits, the disabled, the dispossessed — knowing that from the peripheries of power the world is seen differently. We need to see through the eyes of the South in the South and of the South in the North.

Through the eyes of the women.
It is another way of seeing.
It is another way of knowing.

The domination of nature and cultures is intrinsically connected to the domination of women. There are other ways of acting and knowing the world that are not based on objectification and subjugation. We are beginning to find new kinds of knowledge that weave together reason and intuition, science and mysticism, the logical and lyrical, the personal and political: reaching new depths, creating new visions that are holographic and respond more critically and creatively to the complexities of reality.

There is an urgent need to give voice to these new insights and actions on behalf of the group called women. We have spoken of

sisterhood and have found a common language of oppression, of violence against us, and this has been and continues to be politically important. But it is not enough. Our search for commonality has often hidden the complex patriarchal and political reality of women's lives, riven as they are by caste, class, race and nation. Our illusion of commonality often maintains one truth by excluding the "other", replacing one hegemonic discourse with another hegemonic discourse.

There are differences, and we must acknowledge that we cannot speak for each other. We each come from different experiences, different economic and ethnic locations.

> The knowing self is partial in all its guises — never finished, whole, simply there and original; it is always constructed imperfectly and therefore able to join with another, to see together, without claiming to be another. There is no way to "be" simultaneously in all, or wholly in any of the privileged/subjugated positions structured by gender, race, nation, class. [1]

We need to find new ways to dialogue, new models for a discourse of differences. We need to develop a new ethics of criticism that respects both the differences that cut across and intersect and the unexpected connections that are made possible by dialogue in a paradigm of diversity.

> *And so, the time may come*
> *when women all over Asia*
> *when peoples of the earth*
> *can bring their gifts to the fire*
> *and look into each other's faces*
> *unafraid.* [2]

The World Conference on Human Rights

A consensus document, the Vienna Declaration and Plan of Action 1993, was adopted in June 1993 by 160 countries attending the second World Conference on Human Rights in Vienna. To the millions of people all over the world who are victims of human rights violations, it brought little hope. The Vienna Declaration speaks more in its silences than by what it says.

The Declaration is addressed to the governments of the world and confines itself to the policies and politics of the nation-state system. The state is the protector and promoter of human rights. The document

re-affirms "the important and constructive role played by national institutions for the promotion and protection of human rights" and recognizes the right of each state "to choose the framework which is best suited to its particular needs" (II,23). It even recommends a "national action plan" by which a state could identify steps to improve its protection and promotion of human rights.

But the silence of the Vienna Declaration on the role of the state as violator of human rights has the effect of legitimizing state violence and state terrorism. Poverty, famine, malnutrition, multinationals, ecological destruction and technological terrorism are not recognized as forms of violence which the state perpetrates on its own people through its development models, technological choices, wars and weapons culture.

While the Declaration reiterates that the right to development — as established in the 1986 Declaration on the Right to Development — is "an integral part of fundamental human rights" and speaks of "development facilitating human rights" (II,6), it is silent about the development model itself. The fundamental tenets of the development paradigm — progress, productivity, profits — are left untouched.

The development model underlying the Vienna Declaration has brought with it the dispossession of the majority of people, the desacralizing of nature, the destruction of the way of life of entire cultures, the degradation of women. Such "development" reduces all differences into a flatland called modernity, in which dams displace people and forests and rivers become resources. Against this dominant model of development, technology and nation-state power, manipulated by world financial institutions and global market forces, talk of a "new world order" or "North-South dialogue" or "self-reliance" is no more than a political technique for seeking concessions without ever touching the essence of the existing order. The right to development must be read together with the silences of the Declaration on the right to livelihood, health, education and housing. [3]

The Declaration is also silent on the notion of community and community rights. The understanding of human rights which informs it is an understanding of the human being as an independent, isolated citizen. Human societies are made up of tribes, of castes, of communities from which people gather strength and wisdom, but the dominant human rights discourse has no place for the notion of community and offers no mechanisms for redressing the violence done to whole communities and collectivities of people. Religious, linguis-

tic, ethnic minorities are only given rights as persons: "the persons belonging to a minority have the right to have their own culture, to profess and practice their own religion, to use their own language" (para. 10). But the Declaration is silent on the rights of minorities as peoples, as communities.

One of the cornerstones of the international human rights instruments is the right to private property. But there is no corresponding notion of *collective property* or of protecting it. Thus, for example, the knowledge which indigenous peoples have received through their traditional culture about bio-diversity and how to maintain and develop it is not understood as the property of the whole people. This knowledge is now being sought for the mainstream and commercialized, dragged into the debate on intellectual property rights. Once it is labelled as private property, copyrights and contracts easily follow. Compensation will have nothing to do with the local communities, who anyway will become "national resources". To be sure, the Vienna Declaration recognizes the "unique contribution of the indigenous people" (para. 11). It reaffirms the commitment of the international community to their "enjoyment of the fruits of sustainable development" — in whose name they will now be utterly impoverished. It recognizes "the value and diversity of their distinct identities, cultures and social organizations" — and proceeds to make them faceless citizens mediated and manipulated by the market.

Again, while the Declaration recognizes that "the gross violations of human rights, including in armed conflicts, are among the multiple and complex factors leading to the displacement of people", it is silent on the causes of this displacement other than situations of armed conflict: ethnic, communal or sectarian strife, state development policies (such as the Narmada Dam in India), environmental degradation, nuclear weapons testing, nuclear power plants, toxic and nuclear waste dumping which make their habitats and homes impossible to live in.

The paragraph on response mechanisms, voluntary repatriation and the responsibilities of states, particularly as it relates to the countries of origin, is silent on the resettlement of refugees in third countries, thus seeming to indicate a distinct shift in international refugee policy. Apparently refugees in the South (and now in Eastern Europe) must find their own solutions, their own spaces. The North has closed its doors. It is also silent on the displacement of indigenous people and on the fact that the majority of them are women, who are

often subjected to rape and other forms of sexual abuse and violence. The existing Convention and Protocol on Refugees gives no recognition of a right to asylum or refugee status on the basis of sexual abuse against women. Woven into the matrix of the international human rights instruments on refugees is a clear notion of what is political, and violence against women is not seen as political.

Women's rights are clearly on the world's human rights' agenda. The Vienna Declaration speaks of deep concern over the "various forms of discrimination or violence which women continue to be exposed to all over the world" (Preamble, 7). The human rights of women and the girl child are said to be an indivisible and integral part of universal human rights, and all gender-based violence and exploitation, including that resulting from cultural prejudice, must be eliminated (II,9). Section C.3 of Part III, on the equal status and human rights of Woman, perhaps represents the greatest gain for women in the Declaration: governments are urged to work towards the elimination of violence against women in public and private life. Thus a whole area of hidden violence may now be named as human rights violations. The UN general assembly is asked to adopt the Draft Declaration on Violence Against Women, and states are urged to control violence against women in accordance with its provisions and to ratify the convention on the Elimination of All Forms of Discrimination Against Women by the year 2000.

However, this set of women's rights is again placed within the nation-state paradigm: promotion and protection of these rights are responsibilities of the state, "by legal measures and through national action and international cooperation". The extent to which resolutions, recommendations and special rapporteurs can help to dismantle the entire patriarchal worldview informing international human rights discourse and covenants is difficult to determine. What is important to underscore is that we need to extend the existing terrain to include a gender perspective. As the Declaration on Human Rights by nongovernmental organizations in Bangkok in March 1993 noted: "Women's realities and the violation of their human rights are not reflected either in the language, substance or interpretation of most international human rights documents."

Consequently the claim to universality of the existing notion of human rights is seriously flawed, leaving out as it does half of humanity. The ideology that pervades this discourse disparages women and defines them as the "other"; the process of gender

socialization violates these fundamental human rights and confines them as the "other".

While we need to deepen existing human rights discourse by integrating a gender perspective, we also need a new generation of women's rights. We need new ventures, new visions, new understandings of human rights that are relevant to our violent times. And this is possible if we are willing to unearth the truth in all our universals — war, science, development, human rights, patriarchy.

The universal mode

The South has too long accepted a worldview that has hegemonized its cultures, decided its development model, defined its aesthetic categories, outlined its military face, determined its science and technology. The philosophical, ideological and political roots of this cosmology are embedded in the specific historical context of the culture of the West. The vision in which the centre of the world was Europe and later North America encapsulated all civilizations into its own frames, reduced their cultural diversities into a schema called "civilization", announced that what was relevant to the West had to be the model for the rest of the world. What was good for the centre must also be meaningful for the periphery. The Western simply became "universal".

Every other civilization and system of knowledge was defined by comparison with this paradigm. All social totalities were reduced to the one single model, all systems of science to one mega-science, all indigenous medicine to one imperial medicine, all knowledge to the one established regime of thought, all development to gross national product, patterns of consumption and industrialization. This cosmos of values has determined the world's thought patterns and ecological patterns. It indicates the scientific signs, provides the development symbols, generates the military psyche, defines knowledge in terms of "universal truths" which are blind to culture, race, class and gender — universal patriarchal truths, whatever the cultural ethos, whatever the civilizational idiom.

This universal mode has a deep commitment to a "scientific" cosmology. Underlying its fundamental categories is a construction of knowledge that is rational, objective, neutral, linear and also patriarchal. Cosmologies that did not fit into this framework were dismissed and ridiculed. The cosmologies of "other" civilizations were submerged; the knowledge of "other" peoples, of women, destroyed.

The founding fathers of modern science from the 17th century onwards described the universe as a well-organized machine. To Galileo, nature spoke in quantifiables; Newton could explain everything in fundamental measurables; the philosophy of Descartes was mathematical in its essential nature. The laws of the physical sciences were extended to developing the laws of society, and only that which could be quantified, measured and empirically determined was of any value and consequence. By adopting this Cartesian framework, the social sciences reduced complex phenomena into collectable, manageable and, more important, controllable data. Everything that is scientific is certain, evident knowledge; everything else must be rejected. What happened then to facts that would not adjust into the existing scientific frames? What became of phenomena that could not be measured by the various scientific methods? What happened to work that could not be tied to wages and a market economy?

By separating all the qualities of life from the quantities of which they are a part, and then eliminating them, the architects of the machine worldview were left with a cold, inert universe made up entirely of dead matter. This cosmology laid the basis for a thorough "desacralization of all forms of life during the ensuing industrial age". [4] Nature became an object, a mere mechanism, insensate matter organized in accordance with mechanical laws. Descartes considered all living creatures "soulless automata", ushering in an epoch of unbridled economic, environmental and human exploitation. Darwin extended the idea of a mechanical universe into a theory of the origin of the species. "Darwinism and its theory of natural selection provided the best cosmological defense of industrialism… Social Darwinism served as the main piece for the politics of the Industrial Age." [5] The privileges of the powerful and the elimination of the weak and powerless could be rationalized by appealing to the universal laws of nature.

Marx and Engels extended Darwin's law of evolution to society and human history. Darwin, Marx and Engels and all the other "fathers" shared the same cosmology in which man was the centre of the cosmos, nature was to be used and the universe and society worked according to definite laws. This cosmology exalted competition, power and violence over convention, ethics and religion.

Modern science evolved at a particular historical moment, alongside the rise of industrial capital and the market economy, the philosophy of possessive individualism and utilitarianism and the

polity and politics of the nation-state. At the same time, Evelyn Fox Keller remarks, "it evolved in conjunction with and helped to shape a particular ideology of gender... Gender ideology was a crucial mediator between the birth of modern science and the economic and political changes of the time."[6] The new worldview abounded in sexual metaphor and patriarchal imagery. Bacon often used the language of gender to describe the new science as power: "a force virile enough to penetrate and subdue nature, to bind nature to man's service and make her his slave" and thus to achieve "the dominion of man over the universe". Nature is mysterious, passive, inert, female; and the new scientists spoke of dominating her, manipulating her, transforming her. Bacon's purpose was not to know nature but to control her, to gain power over her. "Masculine philosophers either conceived of nature as an alluring female, virgin, mysterious and challenging" or in their minds killed off nature entirely, writing of it as "mere matter, lifeless, barren, unmysterious, above all unthreatening, but still female".[7] The maleness of Mind and the femaleness of Matter has been significant in the construction of gender in relation to the dominant ideals of knowledge.

This construction of knowledge brought new meanings to the world. But although science and its worldview may use its tools of quantification and objectification to explain the appearance, even the structure of phenomena, it does not and cannot capture their essence. It reduces the history of whole peoples into frames of progress, into lines of poverty, into models of development; it writes the history of entire epochs without mentioning the women who are half of human experience. In so doing it can never reach the depths of the different rhythms of cultures, never grasp the meaning of the different spheres of civilizations, never understand the different cosmologies of women, dalits, indigenous people, the marginalized and the silenced.

Progress is the universal measuring stick of modernity. Underlying it is a substratum of intolerance and violence. It reduces the cultures of the third world to a single uniform monoculture. The concept of the linear movement of progress is intrinsic to the typology of the evolutionary scientists who describe society in stages: a hunting culture is more primitive and therefore less civilized than an agrarian one, and that in turn more primitive than one committed to the industrial mode. The industrialized society represents the peak of progress to which the "other" civilizations must aspire. The dominant mode must become universal.

This linear mode of thought determines not only civilizations but also consciousness. It becomes the norm by which "other" consciousness is measured — "other" meaning third world and women. Consciousness is stratified into higher and lower states: the higher is the rational, objective, scientific, masculine, while the lower levels of "false consciousness" are populated by women, dalits, indigenous and other oppressed people. This "false consciousness" of the masses must be inculcated with a "scientific temper", so that the ultimate goal is attained: "people becoming rational and objective... favouring a universalist outlook", according to an October 1980 statement on "scientific temper" signed by a group of scientists and social scientists in India. This "scientific establishment" goes on to describe the "scientific temper" that must permeate our society as

> neither a collection of knowledge or facts, although it promotes such knowledge; nor is it rationalism, although it promotes rational thinking. It is something more. It is an attitude of mind which calls for a particular outlook and pattern of behaviour. It is of "universal" applicability and has to permeate through our society as the dominant value system, powerfully influencing the way we think.

Ashis Nandy in a lecture on "Science, Authoritarianism, Culture", analyzes how modern science is deeply structured isolation:

> Our future, as we all know in this society, is being conceptualized and shaped by the modern witchcraft called the science of economics. If we do not love such a future, scientific child-rearing and scientific psychology are waiting to cure us of such false values, and the various schools of psychotherapy are ready to certify us as dangerous neurotics. Another set of modern witch doctors have taken over the responsibility of making even the revolutionaries among us scientific.

All this can be justified in the pursuit of scientific knowledge, in the development of a scientific temper, in the inculcation of a scientific worldview — the one, monolithic cosmology that must subsume all; legitimizing itself in the name of universalism.

But what if this worldview, which has depended on a logic of time-lines, is erroneous? What if the most fundamental error is the search for mono-causation? "What if the world is really a field of inter-connecting events arranged in patterns of multiple meaning?"[8] What if the scientific worldview is only one of many? What would happen to science and social science, which have become mega-industries? Scientists and social scientists, who need their power and

privileges, are part of an ideological status quo which needs the universality of the social sciences, with their assumed value-neutrality, rationality and objectivity, to legitimize a violent social order and reproduce it nationally and internationally.

Science explains the world by drawing a clear line between subject and object — objects being whatever can be measured, managed, manipulated: third world, machines, drugs, weapons, women. It then proceeds to collect and collate data, to fragment, to arrange and analyze, to fit the object into categories and concepts and explain it in a language so confusing that it has nothing to do with reality. Separating subject from object distances the observer from the observed. It fractures the human being, dividing the human self from human knowledge, the professional from the personal, the personal from the political. It tears not only the "subjective social world from the objective one, idealism from materialism", but also "involvement and emotion from reason and analysis". [9]

Just as the Eurocentric knowledge construct made the West the "universal", excluding other civilizations and cultures, so in its androcentric dimension the male became the norm and excluded the feminine. This knowledge generated a patriarchal scholarship in which the lives and experiences of women were invisible. "The codification of knowledge is a cumulative process with silence built on silence... For generations women have been silenced in patriarchal discourse, unable to have their meanings encoded and accepted in the social repositories of knowledge." [10] The concept of power enshrined in the different disciplines and social order is one that the male uses: the power to control and manipulate, the power of the winner. This concept of patriarchal power pervades all cultures. In cultures where concepts of woman power exist, it has been pushed to the periphery of knowledge, of life.

Moving out of the patriarchal mindset would mean refusing the mono-dimensional definition of power, seeking to redefine and relocate power, to discover an alternate concept of power, to find new patterns of power. The modern worldview isolates. It divides ideas from feelings, developing the capacity to take ideas to their objective, rational conclusion without being burdened by feelings. Real science requires the suppression of emotions, for there are no categories that can contain personal experience, no mathematical formulas to measure emotions, no place amidst the obsession with objectivity to explain the subjective.

Modern science and its worldview brought new meanings of violence to the world. In the dominant paradigm there is no concept of sacredness. There is no place for a Black Elk who sees "in the sacred manner of the world". Nature, the earth, is resource, forests are resources, diverse species are resources. All the answers to the world's problems will come, we are told, from science, technology, development, which are all part of a global terrorism that has not only destroyed cultures and civilizations but denigrated women and desacralized nature.

Environment has become the new universalism. Many of the deliberations and visions of the UN Conference on Environment and Development in 1992 were based on the report *Our Common Future*. Among other things it spelled out what it considered "global commons" — the oceans, space, Antarctica. Suddenly, it seemed, there was a unanimous report, drawing from a common analysis and perspective, for the world community, identifying common goals, agreeing on common action towards a vision of a common future. What it did not spell out was that "common future" would come by way of a common market place. Many years ago the North American native Chief Seattle's words of wisdom spoke of the commons: "How can you buy or sell the sky? We do not own the air or the water. How do you buy them from us?" How do you now want to control the commons? In the vision for a common future, there is no place for a multiplicity of futures; no place for differences; no place for a plurality of cultures.

The gendered politics of human rights

Women all over the world are finding their voices in their anguish and anger, making what have been understood as private sorrows into public crimes. Violence against women — rape, incest, prostitution, dowry burning, genital mutilation, battering, pornography — has been seen as personal violence, as a domestic problem, and thus privatized and individualized. These are crimes against half of humanity, violations of the human rights of women, total negations of the right to be human, yet they are tolerated publicly in all social systems and in different cultural contexts. "Some acts of violence are not crimes in law, others are legitimized in custom or court opinion and most are blamed on the victims themselves."[11] In being relegated to the personal realm, these crimes against women were refused a place in the political domain. Women have thus been excluded from the

precepts and praxis of the main human rights discourse. The parameters that define the discourse have been heedless of and blinded to gender. The paradigms that determine political thinking and institutions in our times have been based on legitimated discrimination against and degradation of women.

Thus the search for a new understanding of human rights which takes account of feminist concerns cannot follow the existing analytical frameworks, which have denied, excluded and erased women. If we must look for a new understanding of human rights, then we must look *with new eyes*. To do so, we must perhaps begin by unearthing the truth in all the "universals" and look more closely at what has been accepted as the universal concept of human rights for all peoples and all nations. This understanding, which has informed classical human rights thinking, is enshrined in all the international legal human rights instruments, determining contemporary political institutions and the human rights discourse in our times.

Historically, the philosophical and ideological foundations of human rights are in the liberal creed of the Enlightenment period, which ushered in the industrial mode of production, the market economy and the nation-state system, along with a materialist ethic and a cosmology that proclaimed a society in which everyone would be committed to the rational pursuit of self-interest. The liberal philosophers announced their political programme "through private endeavour". Their political faith was anchored in the concept of possessive individualism, which essentially meant that the individual, unrelated to society, was the proprietor of his own person and capacities. They emphasized the importance of private interests, private profits; competition and utilitarianism were its cornerstones.

The worldview rooted in these concepts generated the image of the individual who owed nothing to society. A product of the machinations of the market economy and human labour, the individual, like every other commodity, could be bought and sold, beaten and used. This point of view was encouraged and propagated by those sectors of society which in their attempt to develop their "self-interest" converted human rights into the rights of the privileged and powerful. Over the centuries, human rights came to mean that the claims of the strong and the powerful took precedence over those of the powerless. In order for some classes to have human rights, the masses had to surrender their right to be human. As we have seen, the ideological and political moorings of this understanding are embedded in the

specific historical context of the culture of the West. What qualified it to be termed universal?

In these exploitative aspects of liberal society the concept of the sovereign state developed. The state was seen as the guarantor of individual freedoms. A strong state could prevent the disintegrative forces of the market economy from breaking up society. This kind of liberal rhetoric provided the basis for the Universal Declaration of Human Rights as it addressed itself to the sovereign nation-states of the United Nations. The fiction of the social contract underlying the relation between the state and the individual blurred the stratifications and communities in society. Individual rights and freedoms provided the essential tenets on which the edifice of human rights was built, and the nation-state served as the guarantor.

The Universal Declaration of Human Rights, whose signatories are nation-states, clearly elucidates the rights that must be assured to the citizens of the state and gives nation-states the responsibility of upholding them. However, in the name of human rights, these "sovereign" nation-states may then legitimize the most inhuman conditions, the most brutal repression of their own people, since these are seen as "internal" concerns having to do with "law and order" and their "national security".

Human rights discourse and praxis can thus legitimize state violence and terror. Human rights become the expression of politically legitimated power vis-à-vis the rights of the citizens whom it pretends to protect. More important, it legitimates the violence of poverty, famine, malnutrition, multinationals, ecological destruction and technological terrorism, which the state perpetrates on its own people through its development models, technological choices, wars and weapons culture.

And in the traditional human rights discourse there is no place for women. Human rights was born of a specific worldview which endorsed the relegation of women to the private domain. The privatization of crimes and violence against women as a domestic issue made these violations invisible, denying them their public face and any political significance or social reparation. The assumptions of gender intricately woven into the international covenants on human rights articulated in 1948 legitimated the denigration of women. The founding fathers of the liberal tradition from Hegel to Rousseau understood the feminine as woman's biological nature, lack of political consciousness, emotionality, irrationality, all of which made her a threat

to public life and citizenship. Women could contribute by *rearing* citizens but not by *being* citizens. Liberalism and the politics of the nation-state sought to make men good citizens and women good private persons.

Privatizing women not only determined who would be invested with political and human rights, but also drew a line between what was understood as the rational and the emotional, the universal and the particular, the objective and the subjective, mind and matter. For David Hume, the world of the intellect, of matters of state, of universal concerns of justice, of liberty, was man's world. The woman's world was the world of common life, of dailiness, of the vernacular. In John Stuart Mill's famous essay on liberty, he excluded the "backward nations" of the world and women from the rights to liberty. And on this exclusion were built the classical and contemporary human rights ideas and institutions that have denied women the most fundamental human right of all — the right to be human.

Rape in prisons, the sexual dimension of torture, prostitution, sexual terrorism, the feminization of poverty and so on can no longer be classified as personal violence against women. The victims include women of all ages and from all walks of life, as is evident in reports from Amnesty International. The ill-treatment of an old Iranian woman imprisoned in Evin Prison, Teheran, needs retelling:

> She had helped her sons to escape via the roof of her home. She had been beaten so much on the breasts that they were extremely swollen... She was thrown into the cell like a piece of meat and told she should be in hell. The whole cell cried in sympathy because she was so old and she had no idea what she had done.

Guntabahen Ramji, a 22-year-old tribal woman from Sagbara in Gujarat, was stripped in front of a crowd as she was being arrested. On the way to the police station she was raped by four police officers. She was again assaulted and raped at the police station. Later she tried to file a complaint. The police refused, and the doctors at the local hospital would not examine her without written permission from the police. A supreme court commission found evidence of rape, but its recommendations have been totally ignored.

In the Philippines in April 1986, more than 60 soldiers surrounded and searched the house of a family suspected of assisting the New People's Army. While the search was taking place, 14-year old Rosie Paner and her friend Edna Velez returned from church. When the

soldiers left the house they took the two girls away with them, together with another girl whom they had already taken into custody. Witnesses recounted how the soldiers took the three girls about 30 metres away from the house and how they heard shouts and screams. Later in the day, the bodies of the three were found nearby with multiple stab wounds.

Hundreds of students were arrested in Turkey in April 1987 after widespread demonstrations against restrictions on student associations. One was a young woman, Nilufer Aydur, who gave the following testimony at her trial in May before the state security court in Ankara:

> I was taken to Yenimahalle Police Station. My eyes were blindfolded and I was take to a place I do not know. Here I was stripped naked, then I was hosed with ice-cold water and given electric shocks. They wanted me to sign a statement, but I refused. Thereupon they locked me in a single cell with a male student. We were both stripped naked. Under torture they forced the student to assault me sexually. I could not stand it. I agreed to sign their report.

In Sri Lanka, a female detainee described the condition of another woman after interrogation. "She had welt marks all over her body. She could not sit on the floor or squat. When we pressed her for the reason, she said she had been stripped naked and the baton the police used had been forcibly thrust into her vagina."

In Burma one woman who herself had been raped described the rape of a second woman detainee:

> The day following my arrest, a young girl of about 15 was brought to the camp by the soldiers. She was raped in the same room; the four of us were sleeping in the room. She screamed. At first he slapped her, hit her, raped her in front of me. I saw him raping her before my eyes. She cried but because she was beaten, she did not dare cry any longer.

Kwan-in-Suki was a senior majoring in textile design at Seoul National University, South Korea, when she quit school to take a job at a small garment factory in Punchon. She was arrested on a charge of forging the official documents necessary to obtain factory work. During the interrogation, she was repeatedly tortured sexually by Mun Kwi-Dong, the police officer. Her account makes horrendous reading. She was one of the many female political prisoners gang-raped and sexually abused by the police and the Korean Central Intelligence Agency.

The number of woman victims is endless. However, our purpose here is not to make a new list of the disappeared or the dead, but to focus on specific dimensions of suffering and violence related to women who are the victims — dimensions which need to be seen as human rights violations.

Consider the issue of torture. While some women are tortured because of their own political involvement, most are subject to physical and psychological torture because they are related to men who are considered enemies of the state. Often they are forced to witness the torture, beating and assault of children in order to break them during the interrogation process. According to Amnesty International, "the time between arrest and arrival at an official detention centre is particularly dangerous for women. Arrests may occur in remote areas. Those detained may have to be transported long distances to the nearest detention centre. Rarely will there be witnesses to what occurs. During these days women are at great risk of sexual abuse."

The torture chambers of the world are composed predominantly of military men. The torture of women prisoners and detainees has a sado-sexual dimension. The deliberate infliction of physical and mental pain through sexual abuse, sexual harassment and systematic rape forms the greatest part of the torture of women in custody — "by groups of men, by dogs especially trained, by the introduction of brooms, bottles or rats into the vagina", according to Amnesty International. The anguish of imprisonment is compounded by the repeated humiliation of having to grant sexual favours to obtain food for the child or self. The fear of impregnation and the social disgrace of bearing a child out of humiliating acts is constant. Since rape victims are often rejected by their families, the pain and humiliation continue long after the violation.

Rape is a crime through which men express complete control and domination. In Iran, several young women who opposed the Khomeini regime were raped before being executed, because it was believed that virgins go to heaven: thus patriarchal control must be extended to the next world too.

Violence against women refugees takes many different forms, yet under existing policies and protocols, no country in the world recognizes the right to asylum or grants refugee status on the basis of sexual discrimination or violence against women. Everyone lamented how women raped during the war in Bangladesh would never find a place

in their own society: they had "dishonoured their families" because they had lost their virginity; they were "soiled women" and "soiled women are better dead". They needed refuge in every sense of the word, but no country responded to their pleas for refuge. International human rights instruments — in this instance the Protocol and Convention on Refugees — do not see violence against women as a political crime. Although most refugees are women, refugee policies do not deal with the specific violence they experience from all sides — from the enemies, from their own men and from those who claim to help them. It is therefore crucial to extend the area of refugee rights to include sexual discrimination and sexual violence as legitimate grounds for granting refugee status and the right to asylum.

Moreover, female sexual slavery — trafficking in women, forcing women into prostitution for economic security, the kidnapping of girls, the selling of women by poor families to foreign military or local brothels or harems, or as mail-order brides to Western men, the use of women as "guides" for sex tourism — has nowhere been understood in terms of human rights violations. Here again is evidence of the urgency of widening the existing human rights terrain informed by a gender perspective.

Towards a new generation of human rights

The relatively new right recently added to the spectrum of human rights — the right to development — would seem to belong to a new generation of human rights. This concept owes much to the African jurist Keba Mbaye; and in 1986 the United Nations general assembly adopted the Declaration on the Right to Development by an overwhelming vote, with all third world countries voting in favour. The declaration addressed issues ranging from "people-centred" development to the demand for accountability on the part of the "beneficiaries" of development to the principles prescribed. It saw the right to development as a human right and confirmed that human rights are a means as well as an end to development. It specified the right to participation as a central means to realize other rights in the development process. It spoke of a development that empowered people. [12]

In addition to being state-centred — in that the promotion and protection of these rights were the responsibility of the state — the declaration did not call into question the development model itself. The fundamental tenets of the development paradigm were left

untouched: productivity, profits, progress, all tied to a global market economy and consumerist ethic which has in fact created despair and dispossession for the majority of people. This development model has desacralized nature, destroyed the way of life of entire cultures, degraded women. That story is told only by the victims of development.

Listen to people in the many "Green Revolution" areas of the third world, where "miracle seeds" ushered in the new system of commercializing agriculture in the name of development. The technicism of the Green Revolution required an infrastructure of high-yielding seeds, expensive chemical fertilizers, new pesticides (which led to a new generation of pests), water-control facilities and mechanized farming, which pushed the farmers in the third world into the global market and also global politics. It created new markets for multinationals in the third world. Seeds became an important agribusiness. The multinationals built up their own gene banks of seeds developed in their laboratories for sale to the third world. The Green Revolution made deep and painful incisions into the matrix of everyday life in the third world, and it is only one technical fix of this development which is now a "human right".

Listen to the people all over India who have been displaced by the construction of large dams which threaten to destroy commonlands, drown forests, displace the poor. Every major dam in India has displaced thousands of people from the fertile river valleys. They suffer not only economically but also culturally. Compensation through relocation and resettlement — not without coercion — have only worsened their situation. They are, in fact, refugees in their own country.

Listen to people in Irian Jaya who are being violently forced to destroy the sources of their life. The lands on which they depend for subsistence are being forcibly taken by a government apparently anxious in its commitment to modernization to obliterate the tribal ways of life in its islands:

> It regards non-material, animistic cultures as a threat to national integrity and a diminution of the country's progressive image, and seems prepared to go to great lengths and great expense to create, in the words of a government minister, "one kind of man" in Indonesia. And there is evidence of extraordinary brutality towards this end: of tribal villages being burned down and replaced by rows of tin-roofed huts; of forcing farming on a hunting and gathering people..., of their resistance being

met with beatings by police and soldiers, of tribal leaders being publicly tortured to death and of the bombing and strafing from the air of native villages. [13]

This cultural subjugation is accompanied by a global technological terrorism that is ransacking the rain-forests of Irian Jaya, which has become Southeast Asia's last resource base for rain-forest commodities.

> Companies from the US, Europe and especially Japan are signing joint venture deals with Indonesian firms to prospect the reserves of timber, oil and alluvial gold. For example, Scott Paper of the USA is planning to turn 790,000 hectares of land in the south of Irian Jaya into a pulp plantation. Besides this being an ecological disaster, it would mean the displacement of 15,000 tribal people. A Japanese pulping firm is about to start importing wood chips from Southeast Asia's largest remaining mangrove swamp, in the west of the island; the exploitation of alluvial gold in Asmat is being considered; and to make this possible at least 100,000 hectares of forests, rivers, villages would have to be turned over. What will not be considered, in all of this, is the tribal people of Irian Jaya. [14]

Where is the space in the universal human rights discourse for considering violations of the collective rights of people? What legal means of expression and representation are available to cultures and civilizations that are not a part of the dominant modernistic paradigm? How can they resist the plundering and pillaging of their cultures, their land and the resources beneath it, when all this happens in the name of progress, peace and development — to which we now have a human right?

The discourse on human rights is locked into the terrain of the individual and the nation-state. Encapsulated in it is an understanding of the human being as an independent, isolated citizen. But human societies are made up of communities, of tribes, of castes and so on, from which people gather their strength and wisdom. The atomistic liberal notion of man alienated him from nature, separated him from other human beings, destroyed traditional notions of justice and methods of conflict-resolution. Because there is no place in the dominant discourse for the notion of community, there are no mechanisms for redressing the violence done to communities and collectives of peoples. Religious, linguistic, ethnic minorities have rights only as persons belonging to minority communities or groups, not as peoples.

Yet is there not a collective dimension to the individual — collective knowledge, community rights, collective property? The knowledge of indigenous people is knowledge of whole peoples, which they have received from their ancestors over the centuries and developed over time. Now that the world in its "universal" mode needs the "other" knowledge which traditional cultures have of the earth's bio-diversity and how to maintain and develop it, this knowledge must be brought into the mainstream, commercialized and subjected to the debate on intellectual property rights. The right to private property is one of the cornerstones of the dominant cosmology, and once this knowledge is seen as private property, labels and patents and contracts and copyrights follow automatically. Compensation will become the main terrain vis-à-vis the species in the area; it will have nothing to do with the local communities. This traditional knowledge is sacred and collective, but because existing human rights discourse has no concept of collective property there is no mechanism to protect it from the violence of the universal mode.

Women are also to be integrated into this development process. We are to merge into a model whose terms have been defined for us. Such thinking predominated at the beginning of the UN Decade for Women: that with the expansion and diffusion of the development process and the integration of women into it, all would be well. What became increasingly clear over the Decade was that development itself is the problem. A collective document by women at the end of the Decade conference in Nairobi pointed out that over the ten years "women's relative access to economic resources, income and employment has worsened, their burdens of work have increased and their relative and even absolute health, nutritional and educational status has declined". Development destroyed women's productivity both by removing land, water and forests from their management and control and through the ecological destruction of soil, water and vegetation systems, impairing nature's productivity. As Vandana Shiva says, "while gender subordination and patriarchy are the oldest of oppressions they have taken on new and violent forms through the project of development". [15] We need to be liberated from "development" itself. Gustavo Esteva says it well: "My people are tired of development... They just want to live."

But what does the right to life mean to the peoples who are victims of nuclear testing in the Pacific, the millions of workers in nuclear plants in India, in Sellafield, in Chelyabinsk, the uranium miners in

Peru, the "jelly babies" in Micronesia, the genetically damaged children born all over the world, the indigenous populations in the US, Canada and Australia?

No one on the Pacific island of Rongelap had ever seen snow until March 1, 1954, when white powdery material began to fall from the sky, nearly four centimetres deep in some places. The children romped and played in it. Not until 48 hours later did US military personnel arrive to inform the people that the white powder was fallout from a thermonuclear device exploded on Bikini Atoll, about 150 km. away. [16] The people were to be evacuated immediately; they were not to eat the fish; the coconuts were contaminated; they could not drink the water. The white rain was poison; the snow was fire.

The fallout caused acute radiation sickness in the inhabited islands. More than 90 percent of the Rongelap children suffered loss of hair and scalp lesions; and there was a high rate of growth retardation and thyroid abnormalities. In 1972, 19-year-old Lekoj Anjain died of leukaemia. He was one year old when he played in the "snow". What did the right to life mean to Lekoj — or to the sixteen million other victims produced by the world's nuclear industry and weapons testing? The nuclear estate in all social systems abrogates all our fundamental freedoms (for example, by the withholding of the right to information and the increasing state surveillance of peace and environmental movements) enshrined in the UN charter and in almost all national constitutions. How does the International Covenant on Genocide apply in a world of nuclear weapons — for however "limited" a nuclear war it would obliterate whole nationalities, whole civilizations?

The concepts and categories are unable to grasp the violence of the times. While we need to extend the horizons and deepen existing human rights discourse, we also need a new generation of human rights. A paradigm that understands human rights as the rights of the powerful must give way to one which sees violations through the eyes of the powerless victims of development, of progress, of technical fixes, whose cultures have been ransacked, whose peoples have been ruined: through the eyes of those who have been on the margins, through the eyes of the South in the South and of the South in the North, through the eyes of women. They will tell us a very different story, and the world needs another story.

For over forty years the cold war idiom defined the ideological arena for *realpolitik*. The South, the third world, provided the actual,

physical arena. All the wars in the world since 1945, except for the one in the former Yugoslavia, have been on the battlegrounds of the South. It is not by coincidence that every time the world has been pushed to a nuclear brink, it has been in the third world — Vietnam, Cuba, Korea.

The global parameters of politics have been shifting, making deep incisions into world polity. New centres of power are emerging which will be increasingly determined by economics and technology rather than military alliances and geopolitics. The new post-cold war order demands new political arrangements, even a new organizing mode. Will this age of the microchip and biotechnology usher in a new cosmology in which the way to the truth will be increasingly technological? The violence of the scientific worldview of the industrial age used and abused nature. What grotesque forms of violence will accompany the cosmology of the coming age of biotechnology, genetic engineering and the new reproductive technologies? What qualities will be superior? What characteristics will make up the hero, the superman, the master race?

Patriarchy and violence

While the cosmology of the new technological era will be increasingly patriarchal, it will also be increasingly violent. In the bloodbath that followed the tearing down of the Babri Masjid in Ayodhya, India, in December 1992, the shrieks and cries of hundreds of women who were gang-raped tore the air. Their humiliation was complete when video cameras filmed them being stripped of their clothes. Ayesha, a 15-year-old, was one of thousands of lives shattered after Ayodhya. With her family, she boarded the Tapti Express on December 10 to escape the communal violence raging in the city. After a short run, the mob forced the train to stop. As people jostled about in the crowded compartment, trying to get off the train, Ayesha was thrown down on the platform. A group of men surrounded her, tore off her clothes and knifed her in the chest. She was then raped several times; an iron rod was inserted into her vagina. She was bodily lifted and dumped into a fire that had been started by the hooligans.

As bearers of tradition and culture and custodians of a morality defined by religious patriarchs, women have always borne the brunt of a fundamentalist vision; for in the dailiness of a woman's life she can lay claim to no identity of her own, constantly having to deny and subsume it to the interests of her family, community and nation. But at

the moment of conflict between communities, her womanhood becomes symbolic of her community honour and she becomes the glorified bearer of its exalted traditions. And therein lies her victimhood. Ironically, this victimhood finds an echo within all communities that are otherwise violently asserting their unique significance vis-à-vis the other.

Women are affected in a myriad of direct and indirect ways in all conflicts between communities. Whenever a community's identity is threatened or when it seeks aggressively to project itself, it does so by closing up all spaces for dissent and change and flaunting fossilized oppressive traditions that largely revolve around women.

While history has left India with a legacy of Hindu-Muslim conflict, Ayodhya has shifted the level of communal violence onto a much larger terrain. The implications of a Hindu majority building up its political base around a predominantly anti-Muslim ideology are frightening. The scale and nature of communal violence have also become more organized over the years. Riots are no longer spontaneous outbursts, but are planned and programmed in detail, executed and then made to appear spontaneous. In Surat, as in Bosnia, rape was used as an integral part of a programme of "ethnic cleansing", showing clearly its evolution from an individual personal crime into a systematic political strategy.

But Ayodhya has become the metaphor for a more grotesque violence, the violence of nationalism, of *Hindutva*, heralding a Hindu militancy ushering in the notion of a Hindu *rashtra* (nation). If women are increasingly being mobilized under the banner of *Hindutva*, it is not because they are being led blindly into the battlefield by the men, but because these forces have been able brilliantly to exploit and extend the sources of empowerment that women have traditionally been given within the security of their homes. Thus while their identity and power have hitherto come from their roles as homemakers (even if always vis-à-vis the interests and priorities of the men in their lives), now they have come out into the streets invested with the additional responsibility of being nation-builders. Today's communal conflicts, unlike earlier ones, demonstrate a process of women's political self-actualization and activization that cannot be easily dismissed with a theory of victimhood and instrumentality.

However, it is also clear that if this fundamentalist ideology provides women a conduit for participation in public life, it continues to do so within an essentially patriarchal framework, for it will still

never allow the ideology of domestication to be totally threatened or — despite the apparent concern with dismantling caste hierarchies — the Brahminical worldview to collapse. Even the women visibly propagating *Hindutva* are still "controllable" by men lurking in the background (either as husbands or families) or they have renounced worldly pursuits and given up men altogether and are therefore "safe" to be released alone into the public arena.

This contradiction is still the most vulnerable aspect of the ideology of *Hindutva*. Women's voices are still not allowed to speak the terms of cultural, political or religious discourse, even within minority and victimized communities, where they have little say in what needs to be done, even when they are directly affected. [17]

The politics of fundamentalism which is enveloping large areas in the world and which strives to hegemonize other faiths can only unleash a cycle of violence. The patriarchal ethic has only violent answers. We need a radical new ethic, another vision of the world. Can we women who sense and know the sacredness of life return the spiritual to the material? Can we rediscover the feminine in the increasingly violent male ethos of civilization? Can we bring back the sacred to the earth? It is not difficult to see that we are at the end of an epoch. Can we find new words, seek new ways, create new possibilities out of the material of the human spirit to transform the existing exploitative social order and discern a greater human potential?

What we need in the world today is a new universalism: not a universalism that denies the many and affirms the one, not a universalism born of Eurocentricities or patriarchalities, but a universalism that recognizes the universal in the specific idioms of civilizations in the world. Such a universalism will not deny the accumulated experience and knowledge of all past generations except those who accept the imposition of monolithic, hegemonic structures. Such a universalism will challenge the logic of our development, science, technology, patriarchy, militarization, nuclearism. It will respect the plurality of the different societies — their philosophies, ideologies, traditions and cultures. Rooted in the particular, in the vernacular, it will find a resonance in the different civilizations, birthing a new cosmology.

This could be the wind from the South, rising in all its grandeur, bringing much to this cosmology: the South Wind as the movements for change in the third world, as the voices of the people, the visions of women, the development of new frameworks, seeking a new

language to describe what it perceives, rupturing existing theoretical categories, challenging the one, objective reality, refusing the mechanistic scientific worldview as the only legitimate one; the South as the discovery of knowledge that has been submerged, the recovery of cosmologies that have been silenced; the South as the finding of new definitions of and creating new paradigms for knowledge and politics.

The South Wind must reclaim both the subjective and the objective modes of knowing, creating richer and deeper structures of knowledge in which the observer is not distanced from the observed, the researcher from the researched, the dancer from the dance. This new cosmology will move away from Eurocentric and androcentric methodologies which only observe and describe, methodologies which quantify, percentify, classify, completely indifferent to phenomena which cannot be contained or explained through its frames. The South Wind invites us to create a new spectrum of methods which depart from the linear mode of thought and perception to one that is more holistic, holographic. It urges us to seek more qualitative methodologies in oral history, experiential analysis, action, in research, poetry, myth, metaphor, magic. The South Wind invites us to a way of knowing that refuses to control and exploit nature, but finds our connectedness to it, so as to place together these fragments, to discern their essence, to move into another space, another time, recapturing hidden knowledges, regenerating forgotten spaces, re-finding other cosmologies, weaving the *razai*, re-weaving the future.

NOTES

[1] Evelyn Fox Keller and Marianne Hirsch, *Conflicts in Feminism*, London, Routledge, 1990.
[2] Starhawk, in Irene Diamond and Gloria Fenan Orenstein, eds, *Re-Weaving the World: The Emergence of Ecofeminism*, San Francisco, Sierra Club Books, 1990.
[3] V. Siddharth, "Turning the Clock Back: A Report from the Vienna Conference", *India Progressive Study Group Newsletter*, Vol. 8, No. 1, Sept. 1993.
[4] Clyde Taylor, "Eurocentric vs New Thought at Edinburgh", mimeographed text, Oct. 1986.
[5] Jeremy Rifkin, *Algeny*, Harmondsworth, UK, Penguin Books, 1984.
[6] Evelyn Fox Keller, *Gender and Science*, New Haven, Yale U.P., 1985.
[7] Brian Easlea, *Fathering the Unthinkable: Masculinity, Science and the Nuclear Arms Race*, London, Pluto Press, 1983.

8 Joan Roberts, ed., *Beyond Intellectual Sexism*, New York, David Mackay.

9 Lis Stanley and Sue Wise, "Back into the Personal: Our Attempt to Construct Feminist Research", in Gloria Bowles and Renate Duelli Klein, eds, *Theories of Women's Studies*, London, Routledge & Kegan Paul, 1983.

10 Dale Spender, *Man Made Language*, London, Routledge & Kegan Paul, 1980.

11 Georgina Ashworth, "Of Violence and Violations: Women and Human Rights", in *Change Thinkbook*, II, London, 1986.

12 James Paul, "International Development Agencies, Human Rights and Human Development Project", *Alternatives*, Vol. 14, Jan. 1989.

13 George Monbiot, "Who Will Speak Up for Irian Jaya?", *Index on Censorship*, Vol. 18, Nos. 6 & 7, July-Aug. 1989.

14 *Ibid.*

15 Vandana Shiva, *Staying Alive: Women, Ecology and Survival in India*, London, Zed Books, 1988.

16 Rosalie Bertell, *No Immediate Danger: Prognosis for a Radioactive Earth*, London, The Women's Press, 1985.

17 Cf. the deposition by Madhu Bhushan before the citizen's tribunal in Ayodhya (New Delhi, July 1993) on the effects of Ayodhya and communalism on women and the women's movements.

3. A Life of Endless Struggle: The Position of Women in Africa

RUTH M. BESHA

When I started thinking about this paper, I subtitled it "signs of hope". But all the evidence before me, including research my colleagues and I have conducted in Tanzania during the last five years or so, monographs on the position of women from around Africa, papers presented at different conferences and the plight of women all around, did not in fact offer any hopeful signs. [1]

The many programmes, plans and even strategies worked on in the last few years, in particular during and after the UN Decade for Women, have created a high degree of gender-sensitization and awareness among governments and other planning agencies. There has been a lot of awareness-building among the great majority of people, men and women, but especially among the women. The rhetoric has helped to ensure that no one at any level in society can ignore the "women question", even if the admission that there is a problem is often very grudging.

But after the papers have been read and put away, the books written and published, the research completed and the reports written, how far has the position of women in Africa really changed in actual economic and social terms? And having raised women's expectations, can the goods be delivered? The answer to both these questions, unfortunately, cannot be positive.

This paper will try to show briefly the present realities in which women in Africa find themselves. I do not deny that some very tangible progress has been made in the situation of some women as a result of all the efforts. A few women occupy positions which would have been unthinkable a few years ago; a number of projects have been initiated, with very positive results; some governments have set

up ministries to deal with women's affairs; donor agencies and charitable organizations have made funds and expertise available to help women grapple with the problems they face. But only a very small proportion of women have been touched by all these efforts, and their successes have sometimes overshadowed the continuing under-development of the many.[2]

The constraints

The hindrances to real progress are both economic and social. From the very beginning, the economic problems of women have been emphasized. The dependence of women on their husbands or fathers was seen as the basis of their lowly position in society, so that if only women could be helped to be economically independent, most if not all of their problems would be over. There was a consistent call for women to involve themselves in "income-generating projects". Both governmental and non-governmental organizations spent a lot of resources on creating projects to put some cash into the hands of women.[3] What has not always been appreciated is why these efforts had a limited impact on women's lives. The reasons usually given include the lack of involvement of the women in planning and executing projects, reliance on outside assistance and the small size of projects. While these were among the general reasons for failure, research has convincingly shown that a more basic problem was the nature of the projects themselves.

In Tanzania, for example, most of these projects concentrated on traditional "women's" activities such as needlework and handicrafts. Sewing machines and handicraft materials were purchased (mostly with money from donor agencies) and distributed to many villages, where women were encouraged to form into groups. At one time, the tie-and-dye business was popular among women's groups in urban centres like Dar es Salaam. However, the market for these products was soon exhausted, and in any case most of these groups did not last long. Thus the economic returns from these enterprises were minimal. But most importantly, these activities seemed irrelevant to the women's needs, and many of them required spending a lot of time outside of the home, time which the majority of women did not have. In the end, most women lost interest. What had been forgotten in planning these projects was that most of the women were mothers and housewives, and the full-time activities connected with these jobs had not changed or diminished. Women were already suffering from too

heavy a workload, especially in rural areas where they are involved in a third full-time job as agricultural producers. The often-repeated clichés that "women are the backbone of agricultural production" and that "women work harder than anybody else" and similar well-meaning pronouncements are true. Because they are true, it makes little sense to call on women to involve themselves in even more time-consuming activities. Terming them "development" does not change this truth.

Production relations in the rural economy have not changed. In fact, the call for women to engage in income-generating activities came at a time when most African countries were facing a very critical economic crisis, epitomized in the problem of foreign debt. Most governments were frantic to generate foreign exchange in order to service these debts. Since most African economies depend on raw materials production, peasants had to be coaxed or even forced to produce more cash crops. In Tanzania, for example, there is a current rule in the rural areas that every household has to have a minimum half acre of a stipulated cash crop, centrally decided for each zone. The implications of this for the already overworked women were quite clear: they had to add even more to their plate.

The options for the women were few. Increasing cash crop production (although it did not put more cash into the hands of the women) meant spending more time planting, weeding, harvesting and processing. The cash crops are generally "owned" by the men, who also control the proceeds from their sale.[4] At the same time, women are almost solely responsible for the production of the food consumed in the family. There is no way in which they can reduce the acreage of these crops. The result is obvious: as the underdeveloped economies are drawn further into capitalist production relations, women are forced to take on more of the burden of supporting the family and men assume less responsibility.[5]

Describing this as an "economic" factor is a misnomer. When we look at the situation more closely, it all boils down to one fact: unequal gender relations still exist in our societies. While most researchers now generally agree that the economic problems women face are a consequence of the inequality which has rendered the women powerless to act, policy-makers, planners and even some women leaders are curiously reluctant to acknowledge that the social constraints women face are a bigger hindrance than the economic ones. It is not difficult to see why this is so. Cultural norms and long-

held traditions are very difficult to change. Even after all the sensitization and awareness-building, one still hears women apologizing: "but this is the tradition", "the woman is expected to do these things, to behave in this way". This apologetic attitude has made changes very difficult to introduce.

Most of us have come to accept the patriarchal relations that rule our lives almost as God-given. But it also seems that many people realize that changing social relationships will mean nothing less than a social revolution. When the majority of women, collectively or individually, start asking the relevant questions, the fabric of society, sewn tightly with the thread of women's subordination for so long, will inevitably be torn into pieces. Some of these relevant questions are: why should we do most of the work and reap the least benefit? Why should we work harder than men? What are men doing? Why can't we own land and the other means of production? In the event of a divorce or separation why is it we who have to quit without anything? What are our rights? What does the law say? Why do we have to do all the household work? Why do we have to take care of everybody else? When these whys increase and multiply and become a genuine song, then things will change.

But it is wishful thinking to expect this to happen soon or without concerted effort. And while such a transformation in Africa is a projection for the future, women now have to grapple with their day-to-day problems. How are they coping? What strategies have they evolved to make their lives more tolerable? In these strategies may lie the seeds of a dynamic movement for change.

Women's opinions

The inflationary policies adopted by many African governments to comply with the master international money-lenders has hit the poor sections of our countries hardest, which means the majority in any case. The women, as the poorest of the poor, have fared worst of all, as the reports of the UN's women's conferences make clear. Women in the urban ghettos have tried to cope with the situation by involving themselves in petty business — hawking, running food stalls, beer-brewing, etc.[6] These activities bring in just the minimum to ensure that their families have at least something to put in their stomachs on a daily basis. For as always, the women have to supplement the low wages that are paid to the workers. The women who remain in the rural areas when the men migrate to town have always subsidized the

wages,[7] for even if the men were to turn over all their earnings to the family purse, it would not be enough to keep the family alive for more than a few days (less than seven days in the case of Tanzania). For the many urban women who have to make do with hardly any help from the men, life becomes intolerable.

Not that the lives of their rural sisters are any better. Because of inflation, in order to meet the same needs as last year, the woman has to produce almost twice as much this year. Because it is sometimes absolutely beyond her powers to produce more, she must turn to other means to generate income. Most of the activities in which women in the rural areas engage have been connected with agriculture, such as petty business in selling cooked foods in nearby urban centres or brewing beer for local consumption. In any case, they opt for those activities which would least disturb their other production and domestic duties.

While all these activities help women to cope with the situation, on their own they would not do much to empower them to change social systems. What is more important is that women are increasingly working together in their various activities, developing a sense of solidarity and togetherness which will in the long run be a key factor in effecting change. These joint efforts are based on age-old cooperative activities among women. In many societies, women have come together to help one another in situations such as childbirth, marriage, death, initiation ceremonies. The cooperative activities women are now engaged in take these traditional joint efforts a step further in keeping with current demands.

Because of the difficulties women face in obtaining credit to start their own small concerns, they are running their own simple but effective lending systems. Women save some money from their various activities and put it together. When there is a substantial sum, it is given to one of the members so she can meet a need which otherwise she would be unable to fill. These payments are made in rotation. Among women in Tanzania, this system is called *upatu*, among the Gikuyu *matega* and in Sierra Leone *osusu*.[8] These help systems operate in both urban and rural areas. Sometimes women provide one another with raw materials such as grain for beer brewing, thus ensuring that none of the members of the group suffers unnecessary hardships. Men sometimes see the power of such groups as a threat, and there are cases in which husbands have beaten up or threatened to divorce their wives if they continued to belong to these groups.[9]

This last point brings into focus some of the social options facing women. A number of women are redefining their relationships, especially at the point of choosing between a beneficial scheme and an encumbering marital relationship. There is evidence that many more women than before are moving out of such relationships and setting up life on their own with their children, especially in urban areas. In cities such as Dar es Salaam social welfare departments are having to deal with many such cases, proving that women are no longer ready to accept oppressive relationships. There is also an increasing tendency for women to choose a single life.

These changing social relationships will definitely have an effect on established cultural and even religious practices. It seems that, even though still in a small way, women have started to ask "why?". What we are witnessing is, as Patricia Stamp puts it, "a dramatic sharpening of sex-gender contradictions within underdeveloped capitalism".[10]

The role of the church

Christian women in Africa today find themselves in a very difficult position, given the situation we have described. The history of the church has been one of reinforcing the patriarchal values in society. In fact, in dealing with gender inequality, the church has usually lagged behind secular institutions. To be sure, the church has been involved in a great deal of social work, and women have been in the forefront of such activities. But in general there has been a separation between women's life in the church and their personal lives. The same person is expected to operate with two moral codes. For example, we saw in the previous section that one of the activities women in Tanzania engage in to meet the economic needs of their families is beer-brewing. This has usually been condemned by pastors in Sunday sermons, presumably because it erodes moral values, being associated with drunkenness among men and prostitution among women. But what options do the women have? The question of why women must engage in such activities is seldom asked. It is doubtful that it is ever considered that the choice for some women is between selling beer or rearing undernourished children.

The church has made great strides in the last ten years to ensure greater participation by women in its decision-making bodies. There is no reason to applaud the church leaders for such belated steps, as it is no innovation at all. History has shown that women have held

positions of leadership in many societies, especially African ones. The Christian church reversed this trend, coming as it did at a time when the patriarchal relations in Europe were very strong. At the same time, it must be realized that participation is just one among many issues which hinder the equality of men and women within the church. Today, women are grappling with economic and social issues which the church must address. Hiding behind pronounce- ments and social and charitable work will not assist the women. But reports and studies from different areas show that while many church women groups correctly identify the constraints, the mainstream leadership of the church has not yet come to see these issues as a priority.

Often the church's failure to address the issue of gender inequality in society at large forces women to choose between belonging to the church or quitting. There is evidence that a growing number of women, particularly single women and single mothers, are taking the latter option. Some of those who choose to continue belonging to the church end up in extremist religious groups. The church in Africa today must seriously start to address the burning issues as far as women are concerned. At least the church is still alive in Africa, and its members very sincerely identify with it; and of course the majority of those members are women, on whom the life of the church will depend for a long time to come.

Fighting inequality and injustice in whatever form it manifests itself has always been central to the message of the gospel. Christ never compromised with injustice and acted and spoke against the oppression of women in traditional Jewish society. [11] The church today must ask itself whether it is adhering to these principles. When we speak about gender inequality, about women suffering under heavy workloads and discriminatory traditions, we are also talking of Christian women, about relations that exist in Christian families. While the church can be applauded for speaking out against global injustices, its fight against the problems ordinary people face in their day-to-day lives will eventually decide the continued life of the church in Africa as elsewhere.

Looking ahead

Despite all the efforts of the last two decades or so, we have seen that women are operating from a position of weakness, even power- lessness.

For too long women have behaved like martyrs, trying to do the impossible without complaining, and have thus managed, even in the face of a hostile world order, to keep the heart and soul of humanity together. But the problems which face the underdeveloped world today, and Africa in particular, are far larger than the women can handle on their own, even given the efforts they are making to cope with the situation. Consequently, food security, high maternal and infant mortality rates and child malnutrition have become endemic problems everywhere, and no great progress is in view. Many reports have shown a very clear link between these problems and the unequal gender relations in society. Thus child malnutrition and infant mortality, especially in the rural areas, have often been linked not to lack of food — although that could be a contributing factor — but to the heavy workload of the women. [12]

Actions to deal with the problems we have identified have been rather superficial, sometimes *ad hoc* and in the main still "top-down". So far the emphasis has been placed on redressing the imbalance in public positions. Thus many governments and even women's organizations are quite satisfied to cite the number of women on this or that body or in particular positions. We are accustomed to donor agency reports of how successful some projects are in "putting more money into the hands of women" and presumably making them more "independent". All these efforts have been made in the name of "involving women in development" — the assumption being that development is actually taking place. In fact, it must be agreed that there is no development taking place in much of Africa, at least not "development" in the sense of the United Nations definition: "the introduction of new and modified technologies, inevitably accompanied by changes in economic and social organization, with a view to increasing the total output of society's productive resources, human and non-human". What we are witnessing in Africa is rather acute stagnation everywhere.

Where do the women stand in all this? One thing is clear: women must start acting on their own to make sure they have more control of those areas which will make their lives more tolerable and worth living. At the same time, they have to take it upon themselves to ensure that the rest of society also plays its role. We should aim at reaching a point where we no longer have to talk about "women's workload" contributing to malnutrition.

The issue of empowering women has to be addressed seriously, not only in the sense of giving women more positions in decision-

making bodies, but in a broader sense of devising strategies to enable women to fulfil their roles in the most effective way without being exploited. [13] Short of this, even after another two decades of talking, women in Africa will still be living the same life of endless struggle; and that will also mean that our societies as a whole will be unable to escape the vicious circle of powerlessness, poverty and exploitation which characterizes them today.

Fortunately, women have started to be angry about their position. It seems they are more ready now than ever before to act. There is a need to help each other to articulate that anger positively, to direct it and channel it towards creating a better society for us all.

NOTES

[1] Among the research studies drawn on in this paper are R. Besha and B. Koda, *Participation of Women in Political and Public Life: Case Studies of Ingunda Village and Magomeni Ward*, Institute of Development Studies, Women's Study Group, Report for UNESCO, January 1988; A. Nkoma-Wamuza, B. Koda, M. Ngaiza and R. Besha, *Role of Women in Decision-Making at Household and Community Levels: The Case of Iringa and Kagera Regions, Tanzania*, Dar es Salaam, UNICEF, 1989; A. Nkoma-Wamuza, R. Meena and B. Koda, *Women's Strategies in Coping with Household Management in Poor Areas in Dar es Salaam*, Dar es Salaam, UNICEF, 1989; R. Besha and F. Leiser, *Socio-Economic Study in the Southern Highlands of Tanzania (Iringa and Mbeya Regions)*, Bern, Swiss Intercooperation, 1990.

[2] The small impact of all these efforts is clearly set forth in the *Report of the World Conference to Review and Appraise the Achievements of the UN Decade of Women*, New York, United Nations, 1986, esp. paras 43-50, pp.17ff.

[3] Such projects are well-documented in reports of the African Training and Research Centre for Women, UN Economic Commission for Africa, Addis Ababa, Ethiopia. A useful reference on the success of some of these projects is S. Muntemba, ed., *Rural Development and Women: Lessons from the Field*, Geneva, International Labour Office, 1985.

[4] Cf. *Rural Women's Participation in Development*, Evaluation Study No. 3, New York, UN Development Programme, 1980, p.80.

[5] Cf. *ibid.*, p.7: "The family progressively loses its role as a relatively independent economic and social unit. Gradually a large number of both decision-making and other functions are transferred to society at large. In the course of this transformation, men's and women's functions in the private and public spheres of life tend to become more and more lopsided, with men losing touch with family life and problems, and women understanding less and less of the workings of the public machinery."

[6] A study dealing with these issues in the Tanzanian context is Nkoma-Wamuza et al., *Women's Strategies in Coping with Household Management*.

[7] Cf. Ayesh Imam, "The Myth of Equal Opportunity in Nigeria", in Miranda Davies, ed., *Third World, Second Sex 2*, London, Zed Books, 1987.

[8] In addition to the studies of Tanzania cited above (see note 1), for Kenya see Patricia Stamp, "Kikuyu Women's Self-Help Groups: Towards an Understanding of the Relation between Sex-Gender System and Mode of Production in Africa", in Claire Robertson and Iris Berger, eds, *Women and Class in Africa*, Africa Publishing Company, 1986; for Sierra Leone, Filomina Chioma Steady, "Women's Work in Rural Cash Food Systems: The Tombo and Glouster Development Projects, Sierra Leone", in S. Muntemba, *op. cit.*

[9] Cf. Patricia Stamp, *loc. cit*, p.41.

[10] *Ibid.*, p.41.

[11] Cf. *By Our Lives: Stories of Women Today and in the Bible*, Geneva, WCC, 1985.

[12] An article in the *Daily News* (Tanzania), 22 May 1991, cited a study showing "that the number of child deaths due to malnutrition was higher in the first four months of a year, as it was during this time that womenfolk were engaged full-time in farming activities, having little time to care for their children".

[13] Cf. Achola Paya Akeyo, "Towards a New Theory in the Study of Women in Africa", in Mary Adhiambo Mbeo and Oki Ooko-Ombaka, eds, *Law in Kenya*, Nairobi, Public Law Institute, p.11.

CASE STUDIES

4. Australia
The Family Secrets Exhibition

JO BARTER

"Incest and domestic violence are a reality we can all act to change; and because change requires openness and truth, boldness and action, an exhibition is very appropriate." [1]

The Spinsters are a women's action group formed in Melbourne, Australia. It began when women from the Rainforest Action Group (RAG) started meeting informally over dinner to discuss some of the difficulties with being a woman in a large mixed activist group. From these cosy gatherings it was decided to form a women's action group to explore nonviolent action around women's concerns. The group was closely linked with the Melbourne nonviolence network as well as the RAG community.

All of us were in our twenties, and we enjoyed reclaiming the word "spinster". Since spinning was historically a very common occupation for women, any woman who was financially self-reliant was likely to be a spinster. Only later did it become a derogatory term for an unmarried woman. Together we began spinning trust and ideas.

It was hard at first to decide our political focus, as we had so many wild suggestions, but one woman's idea stuck. We decided to organize an exhibition of art work by survivors of incest and domestic violence. Intuitively, this focus came from our hearts, and later we discovered that eight of us had in fact survived incest. All of us had a deep understanding and strong feelings about living in a violent society. Thus the main source of power for our political work was our emotions. We followed our feelings.

Over five months we worked very closely with each other, sharing stories, emotions, plans and ideas, discussing our aims, imagining and

supporting each other. We knew that the hub of the web we were spinning needed to be strong. We became a unified, empowered collective.

"Spinsters; women gathering...
Women laughing; deep raucous, unself-conscious laughing.
Women celebrating; celebrating our beauty, our power."

Our aim was to take steps towards creating a world in which power is shared equally between men and women. We hoped to empower women and tackle the values, attitudes, behaviours and structural causes of the oppression faced by women and children living in a sexist society. Feminism and nonviolence gave us a framework for exploring the complexities of the issues of domestic violence and incest, a framework that allows us to express anger at the injustice of the oppression perpetrated by fathers, brothers, grandfathers and other loved ones, but still to affirm the sacredness of all human life. Feminist nonviolence does not offer condemnation or mere punishment; it beckons and challenges us all to change.

"The Spinsters: women dizzily, determinedly, infectiously SPIN-
NING."

We met weekly, sharing all the tasks and making decisions by consensus. Our meetings were busy, full of laughter and excitement, but also anxiety when the project seemed daunting. We learned new skills together, since none of us had ever held an exhibition before. This meant helping each other to confront many difficulties and fears as we gathered contributions, did media advertising, established timelines, looked for venues, revised timelines.

"I had to deal with a lot of fear when I was doing media — fear
instilled to stop me from telling the truth of what goes on."

We started encountering false assumptions in the community arising from women taking action against domestic violence and incest. For example, the manager of one venue asked, "It's not going to be man-hating, is it?" The Spinsters meetings became a place to share our adventures, and we enjoyed the safety and solidarity of being a women-only group.

"I know a great bunch of women, all these wonderful women
that have come together, all the talents and resources.
***Nothing** is going to stop me now."*

We had a "creating day" for ourselves and our friends. We painted, talked of our experiences and watched videos on domestic violence.

"In this relaxed atmosphere I could feel my rusty old primary school creativity begin to flow again. I created my first-ever painting and first-ever sculpture and first-ever song!"

From this centre of empowerment and trust our web grew...

The Family Secrets exhibition

"We knew that if we received just one contribution, the exhibition was a success, because one person had unlocked a secret for all and was able to express feelings of hurt and pain — one person was healing.

*"I remember our excitement when the first contribution came in the mail. We were ecstatic — only one contribution — but we **knew** that it meant the exhibition was on!"*

The Family Secrets exhibition was held at the Footscray Community Arts Centre in September 1990. It consisted of paintings, poetry, stories, tapestry, weaving, pastel and pencil drawings and sculptures by survivors of incest and domestic violence. Most of the contributors were women, but there were also four men, including one from Men Against Patriarchy. Many of the contributors had never exhibited before, but we were firmly committed to allow any survivor to contribute, regardless of traditional artistic standards, which serve only to exclude artists. Finding the art work was not difficult; there were many brave contributors who dared to speak their truth.

"We arrived at 6 a.m. on the opening day to set up the exhibition. At first there were just five of us. We had no idea how long it would take, so we worked with concentration. Gradually, friends from RAG arrived and then there were so many of us — hanging pictures, climbing ladders; and just as the last label was stuck crowds of people arrived.

"It was a strange feeling after the art work was hung. After months of busy organizing, I suddenly had the time to allow the impact of the Exhibition to sink in. I went off to the nearby river to have a cry of relief that it had worked and a cry of sadness for what women had endured. After the day was over I remember laughing and crying all over again with the Spinsters because we discovered that nearly all of us had gone down to the river that day to cry!"

There were musical performances, a vegetarian feast, champagne and a good turn-out. The exhibition ended with a women-only closing celebration with an evaluation and feedback time, musical performance and belly dancing. We were thrilled at the success of something initiated by eight ordinary women on a shoestring budget of $400 (kindly donated by one of the Spinsters). Unfortunately, attendance the next week was low, probably because the Footscray Community Arts Centre is a little inaccessible and organizing the entire project in five months had meant that we devoted little time to advertising. This was the only substantial flaw of this project.

What the exhibition achieved

One of the main achievements of the exhibition was to empower and give meaningful support to contributors in their healing from incest and domestic violence. We did this by providing a safe place for survivors to give expression to their experiences. This validation is vital since the silence surrounding these issues in society means that women and children remain powerless, and in isolation they face shame, fear, self-hatred, guilt, anger and grief. Survivors have carried the burden of domestic violence and incest for too long.

"I felt guilty for letting it happen…
There is also anger, simmering
like lava before it
splits open the earth."

The strong emotional impact of the exhibition clearly demonstrated the feelings and experiences contributors had endured as abused children and as healing adults. The pain, hope and love were obvious.

"I don't know whether to cry or scream. Such brave, strong women.
It's a powerful and very moving exhibition."

Holding an art exhibition applauded the creativity and the resililience of survivors. It encouraged the use of art work as a powerful form of self-expression. We held a tea party at which contributors could share their stories and receive affirmation for the bravery of their choice to express very personal experiences publicly. We also gave informal one-to-one support and encouragement as women dealt with their difficulties and fears about contributing. We encouraged contributors to participate in organizing their exhibition and in working collectively.

"For the women who have taught me not to be scared
and shown me how to be free again, I thank you."

The exhibition offered inspiration and hope to other survivors seeing
the art work:

"Thanks for sharing so much with me.
So comforting that others have felt how I feel."

As well as providing personal and collective support and empow-
erment, the exhibition was a powerful way to educate the community
about the reality of domestic violence and incest. To expose some of
the common incorrect beliefs that surround this issue, we allowed the
survivors themselves to be heard and set up a public display with
books and videos on domestic violence. The exhibition was a clear
and important public demand that stopping domestic violence and
incest is not to be seen as a private family matter. The community —
and men in particular — are responsible for stopping violence against
women and children.

"I realize now that I can't forgive him until he repents. It would have
to be a lot of work to make up for all his crimes. That's his business."

Revealing the problem

It was clear from the exhibition that many women and children in
Australia do not feel they are growing up in a "lucky country".
Domestic violence occurs in one in three Australian homes; one in
four girls and one in nine boys go through some form of incest by the
age of 18 — and 97 percent of the perpetrators are men. With
staggering statistics like these, it is clear that incest and domestic
violence are not isolated, unusual events.

We had a display board from the Domestic Violence and Incest
Resource Centre defining various forms of domestic violence. Domes-
tic violence includes physical violence, which generally increases in
severity, intensity and frequency over time.

"I remember hands that grope and grab, poke, pinch, hit, slap,
punch, probe, pry."

It may take the form of psychological violence, including emo-
tional and verbal abuse that erode a woman's self-esteem and her
sense of having rights or choices.

"His body, so vital, swallows me up."

It includes social violence that aims to isolate the woman from friends and family.

"He continually patted at our bottoms and fannies; he did it to my high school friends."

It may be economic violence, where there is unequal access to shared resources, or sexual violence — any sexual act or behaviour that is forced on a woman without her consent, including incest, which is any unwanted threatening or violent sexual behaviour by a family member.

"He tried to enter once. I was tensed up so that he couldn't... The pain was searing and getting worse. What was he doing to me? I hardly knew this part of me which he was hurting, tearing, violating. I cried out in anger and fear... He wiped me with a tissue."

The effect of this pervasive violence on women and children is enormous. Often the only choice a woman believes she has is to live with violence, for she risks the real possibility of even greater violence if she leaves. If she does leave, she often faces poverty and a lack of support services to meet her needs. There are even fewer services to meet the needs of children. This profound violation of their rights means that many women and children understand what it means to live in fear. With domestic violence often escalating over time, fear of future violence often becomes the most powerful weapon in the oppression of women.

Domestic violence and incest occur because of three main reasons:
— individual men choose to be violent;
— community attitudes condone male violence against women and children;
— a social context of patriarchy perpetuates gender inequality, which in turn supports this violence.

A patriarchal world values men and upholds stereotypical masculine values, whereas women and stereotypical femininity are undervalued. Society is based on a paradigm of domination and oppression because power is seen only as the ability to control others. Men use violence to reinforce this control over women and children. There is a power imbalance between men and women, with the greatest imbalance being between men and female children, which is a major contributing factor to such widespread incest by fathers against daughters.

This social context of sexist structures and conditioning trains individual men to use violence to meet their needs. Furthermore, the community in general condones this violence and has many erroneous beliefs about domestic violence. For example, an Australian survey found that one respondent in three agreed with the statement that "domestic violence is a private matter that should be handled within the family". [2]

"I don't draw any of these things because INCEST is a secret and shouldn't be acknowledged in public. Besides, if I told anyone, Daddy would take my pencils."

The same survey found that nearly one person in five believed that it is acceptable for a man to use physical force against his wife under certain circumstances. These community attitudes, held by marginally more men than women, form the basis of sexist behaviours in society.

"Spin on, Spinsters!"

The Spinsters' actions stemmed from redefining power. We respect and nurture the personal power each of us has to choose and make decisions about our own lives, which has nothing to do with controlling others. Ultimately, the ability to exert power over others is limited when faced with true power and empowerment, especially when that true power is collective and structural as well as individual. Many men who control and dominate in the family home feel powerless because they do not have a strong sense of personal power which includes taking responsibility for their own actions, feelings and needs. While men do have enormous power over women and children and society accords them privileges, they need to reclaim and be responsible for their share of true, non-oppressive personal power.

"The greatest power is that of love, and women hold a monopoly. Men need liberation."

Nonviolent feminist action offers insights for the future direction of the domestic violence movement in Australia. This movement includes government-funded refuge support groups and domestic violence and incest-specific services. Women's safety and empowerment is a priority for these. There are also political lobbying groups, whose primary focus is on reforming the legal justice system. Together, these groups form a strong and determined part of the women's movement, and they have taken great steps in providing

community education and crisis support in this area. At the same time, this movement is faltering and needs a strategic refocus.

The domestic violence movement is presently hampered severely by its primary focus on legal reform. The legal system is cumbersome, expensive, inaccessible and unjust. Although incest and domestic violence are crimes, focusing on changes in the legal system will never prevent them from occurring. With sexist attitudes so entrenched in society, it is unrealistic to expect much change from improving legislation. Reforming institutions will not bring the needed transformation of attitudes, of behaviours, of *society*.

Another choice the Australian domestic violence movement should reconsider is its reliance on government funding and its consequent adherence to government policies, which emphasize providing individual welfare support and are reluctant to fund daring political action aimed at preventing the causes of violence. Strategy must therefore be short-term and reactionary rather than well planned.

These two main flaws reflect a co-option of the domestic violence movement, which in the 1970s was a radical grassroots movement operating outside existing institutions and demanding fundamental change in society. Now this movement is literally tired. There is high burn-out, high stress levels and a high turnover among workers. A significant amount of time and energy are used in trying to maintain an inadequate standard of funding. There is a frustrating cycle of dealing with women and children escaping violence and never having enough time for preventative work. The last twenty years have seen a shift from dealing with the causes of violence to treating its symptoms.

While the women's movement has responded caringly and effectively to the needs of women and children for safety and refuge from violence, their most pressing need — for the violence to *stop* — remains unmet. Crisis support work must stay within the framework of a political vision for making the world safe for all women and children. Most importantly, this means developing long-term strategies, at a grassroots level, not only at a legal or policy level. It needs to include a decentralized, local community response to incest and domestic violence. It must incorporate the strategic ideas of survivors themselves. Although this will be an enormous challenge, it is vital for it to be an empowering and rejuvenating process for all involved. These ideas are only the tip of the iceberg. Most of all we need a great deal of collective effort by men and women.

The Family Secrets exhibition was one of many possible community-based projects that remained true to the revolutionary spirit of the origins of the domestic violence movement. It was successful because it integrated personal healing and support with political action. With the Spinsters' focus on empowering ourselves, we had a strong base from which to involve others. Creating an exhibition of striking artwork was a positive way to deal with difficult issues. The Spinsters showed that the collective expression of emotions and experiences can be a compelling political act. For us political action has been personally challenging, nurturing and fun. I know that the lives of all the Spinsters were changed by working on this exhibition and there were many dramatic changes in the lives of contributors as well.

Furthermore, the web we began to weave in 1990 is spreading. One of the contributors, inspired by the original exhibition, initiated a new collective of Spinsters in 1992; and in 1993 another Spinsters' exhibition was held called "The Art of Survival", funded by two philanthropic trusts. The exhibition included two nights of performance by survivors and many workshops on related topics; and it was very well attended, being in a more accessible place than the first exhibition.

This was exactly the vision of the original Spinsters: that women would organize their own exhibitions on domestic violence and incest in their local areas. In this way community awareness and the empowerment of women can spread. The beauty of this project is that it can and needs to be repeated anywhere as one step in healing survivors and preventing domestic violence and incest. All it takes is the bravery to speak the unspeakable and the strength and love of ordinary women. Above all, these two exhibitions, and ones of the future, will stand as a tribute to the courage of women and children surviving the unbearable — surviving and thriving!

"Our bodies are sacred,
Our spirit is strong."

NOTES

[1] The italicized quotations throughout this chapter are from survivors of incest and domestic violence who were part of the Spinsters collective or visited or contributed to the exhibition. They are anonymous in order to maintain confidentiality.

[2] Cited in *Violence Today*, no. 2, National Committee on Violence, Woden, ACT.

5. *Cameroon*

Halting Violence Against Women

Two factors led in the early 1990s to the establishment of *L'association de lutte contre les violences faites aux femmes* (ALVF: Association to Halt Violence Against Women) in Cameroon. One was the death in 1990 of three women in Yaoundé: a primary school headmistress who was repeatedly beaten over a period of three days by her husband, a high school teacher whose husband hit her over the head with an iron and killed her, and a housewife, seven months pregnant, who was battered to death by her husband.

The other factor was a growing protest against the absence of women from the political debate accompanying the opening to democracy and introduction of a multi-party system in the country in 1991. In July the minister of territorial administration banned CEFER, Cameroon's first feminist association, from carrying out its activities, along with ten other human rights groups which had taken part in a meeting of the coordinating body of the opposition parties.

Outraged by the murder of these three women, the apparent impunity of their aggressors and the passive connivance of public opinion, and dismissed as unrealistic activists by the opposition parties and among the general public, five veteran militant feminists and two other women decided to join forces and continue their struggle by setting up a framework for action by women, despite being muzzled by the ban. Their method would be to defend the honour of women and speak out vigorously and persistently against all the daily violations of their dignity, whether perpetrated by the state, by civil society or in the family.

Their first aim was to break the silence surrounding the issue of violence against women and thus challenge the women of Cameroon

to adopt a different vision of social change — one in which violence against women would be seen as unacceptable in a democratic society. On 15 November 1991 the Association obtained legal status.

The philosophy and aims of ALVF

In its struggle to stop violence against women, ALVF is inspired by the model of feminist thought which puts women at the centre of its questioning. Unlike institutional responses, we are aware of the specific handicaps women must overcome in order to enjoy their rights as citizens on an equal footing with men and to be able to speak out against the social injustices arising from the present system.

ALVF seeks to make women aware of the specific conditions affecting them and the factors which perpetuate oppression, to help women develop a personal sense of identity by becoming more independent and assertive in their own lives and to promote openness to social change among women.

The general aims of the organization are: (1) to make public opinion and institutions aware of the need to improve the condition of women in all sectors (politics, society, economics, education); (2) to draw attention to the causes and consequences of the various forms of violence suffered by women and how this affects their ability to take a full part in public affairs; (3) to mobilize women by providing simple, easily accessible information and creating formal and informal means to enable them to defend themselves against violence; and (4) to establish new legal and operational structures to defend and protect women's rights.

Achieving the aims: four strategies

To achieve its aims ALVF has created residential centres for women, organized awareness-building campaigns, related with other organizations and engaged in research.

1. In the ALVF *residential centres for women* in Yaoundé, Bafoussam and Douala, women who have been brutalized are received with understanding rather than a critical or judgmental attitude. To create a friendly place that both provides support and solidarity and works effectively against the age-old victimization of women, we follow an approach which emphasizes action by women against individual and collective violence.

The centres offer an alternative to typical social institutions, in which women subjected to violence are prevented from speaking out

because of the traditional role of women in a hostile, unjust and sometimes even fatal environment. They aim to break the silence — and thus the growing fear — surrounding violence against women by refusing to allow acts of violence to be treated as something trivial and by giving women victims of violence the freedom to speak. They also seek to provide women an escape from violence by informing them of their rights, strengthening solidarity among families and developing social solidarity among neighbours. A third aim is to help women to gain the psychological and material independence to recover the identity and self-esteem destroyed by the violence to which they have been subjected. Finally, the residential centres create a network to help women who have been victims of violence and enforce respect for the basic rights of women.

Those coming to the centres are given information about possible solutions, about the means of prosecuting their aggressors through the judiciary and about practical steps for acquiring the means to act for themselves. Guidance and advice are offered on medical needs, family planning, legal matters, available psychotherapists, other specialized non-governmental organizations (NGOs) and other specialists. Help with official formalities and first aid for medical and other emergencies are available. Workshops are conducted on a range of subjects, including alcoholism, contraception, divorce, rape, incest, widowhood rites and excision. A library offers reading materials, including women's writings, documentation on feminism and information about other NGOs and women's associations.

2. *Awareness campaigns* have been directed both at women and to the general public. They aim to bring domestic violence into the open and give brutalized women the courage to speak; condemn the reasons underlying violence and its impact on women's physical, moral and psychological health; speak out against the social connivance which allows these crimes against women to continue; make the public aware of these crimes; and encourage reflection on new legal provisions to help women.

Campaigns have been conducted through the public media (radio, television, press), the publication of posters, pamphlets and tracts and the organization of round-tables, conferences and celebrations to commemorate events in the women's struggle. So far we have had campaigns on marital violence, clandestine abortion, and women's voting and participation in public affairs.

3. Because the struggle is too bitter to conduct alone, ALVF maintains ongoing *relations with other organizations defending individual rights*. Without the experience of others we cannot make progress, so we have adopted a strategy of exchange. We take part in meetings and organize exchanges of views with other NGOs and associations for the defence of individual rights in our country.

In March 1992 ALVF organized the first seminar on strategies to halt violence against women in French-speaking Africa. It was agreed to hold a similar workshop every two years to evaluate these strategies. The first was held in Bamako, Mali, in February 1994. A seminar in Yaoundé in 1992 initiated a network of NGOs and associations in French-speaking Africa engaged in the struggle to halt violence against women.

To bring violence against women in Cameroon into the open and to contribute to the development of global strategies to combat it, ALVF also takes part in international gatherings where women's rights are discussed — among them the international seminar in Vienna at the time of the world human rights conference, the seventh world congress on women's health in Uganda in September 1993, a consultative seminar on violence against women in May 1994 and a preparatory meeting in Brazil for the September 1994 UN conference on population and development in Cairo, as well as the Cairo conference itself.

4. In order to be able to speak out against the social mechanisms that underpin and perpetuate violence, ALVF plans to carry out *research* on different subjects. Two aspects already identified for study are women victims of violence and their reception in public structures, using the case-study of Yaoundé (in progress), and widowhood rites in western Cameroon (for which funds are being sought).

6. Canada
After the Massacre

LYNN GRANKE

The worst single-day massacre in Canadian history took place on 6 December 1989, when Marc Lepine walked into the Ecole Polytechnique (engineering school) of the University of Montreal and opened fire in two classrooms and the cafeteria. Entering one of the classrooms, Lepine told the women to stand on one side of the room and ordered the 48 men to leave. As he fired the first shots, he shouted, "You're all a bunch of feminists, and I hate feminists." Lepine killed 14 young women and injured 13 others before turning the gun on himself. The suicide note found on his body confirmed the motivation for his act. Lepine blamed his unhappiness and failures in life on women. Feminists, he said, had ruined his life.

Canadians, for the most part, were shocked by the news. Many were outraged, others were saddened. The silence and denial about the violence women face each day in Canada was broken. Some Canadians said they were not surprised by the event, that it was inevitable. Francine Pelltier, a journalist with *La Presse* in Montreal, said, "We should be shocked. Never did we think that in the fight for women's emancipation some of us would die." [1] The question was asked, "How could this happen in a civilized, technologically advanced country like Canada?" The answer lies in the silent, untold stories of women. Immediately after the event, women from all social and economic levels, of all races and ages, began telling stories of the daily violence they encounter simply because they are female. Women identified with those who were murdered. They felt as if a part of them had also been victimized.

Was Marc Lepine's act an isolated case of insanity, or did it represent men's attitudes towards women in general? This debate was

already heard at the funeral of the victims, where remarks by mour-
ners ranged from "the man was sick, he was insane" to "this is just a
magnification of what is happening to women all the time". [2] In the
days following the massacre, one survivor told of her distress when
she heard the event described as an isolated act, which some observers
explained by Lepine's poor upbringing. Sylvie Gagnon, a survivor,
countered that viewpoint: "This is the violence I live with every day,
that all women live with — an exaggerated violence, but with exactly
the same intention." [3]

The enormity of this event reminded women of all the small daily
acts of violence they confront: sexual harassment in the workplace and
on the street, sexual assault, verbal and emotional abuse from male
family members and strangers — experiences women live with
throughout their lives. We do not talk about them because individually
they seem insignificant and we accept them as the way life is. Sylvie
Gagnon commented that the event "opened the door on every
woman's little sadnesses. The event touched on all the sadness and
anger that women carry in them like a memory." [4] Francine Pelltier
described how disquieting she found the preoccupation in the media
with the search for reasons to justify Lepine's actions rather than
addressing the issues in his suicide note. Fear and disbelief distracted
us as a society from the larger issue of women's emancipation and the
changing roles for both sexes.

Stories of how some men responded indicate that Lepine's
attitude and actions are representative of many men's feelings
towards women. For example, at Queen's University in Kingston,
Ontario, a campaign against date rape was underway at the time of
the massacre. Some male students felt that all men were made out to
be rapists. In response to the campaign's slogan "No means no",
signs were posted stating "No means kick her in the teeth" and "On
your knees, bitch. No more Mr Nice Guy." [5] That not all men were
outraged by the incident is one indicator of how widely such
attitudes are held. In the days after the massacre the National Action
Committee on the Status of Women, a feminist umbrella organiza-
tion, received a call from one angry man who announced that "Marc
is not alone". A team of psychologists in Montreal who opened their
phone lines to the public for free counselling were told by a number
of male callers that Marc Lepine's actions had stirred their own
anger towards women. One specific caller said, "I am very happy
Lepine did it. You psychologists are just like those women and I am

coming to your office to kill you."[6] He never showed up, but the level of violence and hatred was obvious and intimidating.

Following the massacre some significant, nonviolent responses occurred. Vigils were held on university campuses across the country. In major cities women and men gathered in the hundreds to express their grief, fear and outrage. Women voiced their concerns about and identified with the violence women experience throughout their lives. Lepine's carnage was not an individual act. It was not just one man hating women. The overriding message is that violence and misogyny are the social and political reality we live with.

One Canadian forensic psychiatrist, Herbert Pascoe, believes Lepine's apparent resentment of successful women is widely shared by men within our society: "The fact is that many, many men feel inadequate and inferior in their relations with the opposite sex. And this can show up in some very unpleasant activities."[7] Rosemary Gardner, a sociology professor at the University of Toronto, who has examined homicides of women in 18 industrialized nations between 1950 and 1980, has discovered that as women move into non-traditional roles, they run a significantly higher risk of being killed.[8] This would lead us to believe that men perceive women as a threat to their territory, to male dominance and power in society.

Since the massacre, numerous other deaths of women from male violence have been followed by vigils in cities across Canada. Many of these women were terrorized and abused by husbands or lovers prior to their death. At the vigils, people, predominantly women, gather to share stories of the deceased and their own stories of pain, and to appeal to the government and society for tougher laws to protect women. In Ottawa a permanent monument has been built on which are inscribed the names of women who have died as the result of male violence. As people view the monument they will ask questions about it and so the discussion and education on the subject continue.

Another welcome and significant action has been the white ribbon campaign begun by men frightened by the violence and out of concern and love for the women in their lives. Every December, as the anniversary of the massacre approaches, white lapel ribbons are sold to be worn in remembrance of those who died at the Ecole Polytechnique and as a symbol of commitment to ending violence in our society. Some groups of men have walked between cities to raise awareness of the campaign and to meet with other men, in particular

older adolescents, to discuss male violence. Public debate continues in the press as women and men write letters to the editor expressing opinions on violence and especially male violence. Many of us continue to try to understand the effect on our behaviour of violence on television and in films. One positive outcome of the massacre is that men and women are voicing their refusal to accept male violence as the norm. Women are clear that there is no turning back the clock in terms of women's gains. The year after the massacre the number of women registering at Ecole Polytechnique increased. This is a "no" to Lepine and his violence and a clear signal that women want an equal place in society.

Since the massacre there has been a strengthening of the gun-control lobby, given weight by the support of some of the parents whose daughters were murdered. Many people asked how Marc Lepine, who was denied entry into the Canadian armed forces because of his anti-social behaviour, obtained a semi-automatic weapon so easily. Two women went beyond wondering to action. Heidi Rathjen, a fourth-year student at the Ecole Polytechnique at the time of the massacre, began a petition for stricter gun laws and started organizing briefs to support its presentation to the federal government. Wendy Cukier's response to the massacre and her loss of sense of Canada as a peaceful country was to contact gun-control advocates and develop a network of those who thought similarly. She helped form the Coalition for Gun-Control, which is supported by more than 300 groups nationwide, including police chiefs, the Canadian Bar Association, public health agencies and community organizations. These women, previously unacquainted, made contact with each other and began working together for change.

In the process they encountered opposition: paternalistic responses from the parliamentary committee, eviction from the public gallery of parliament for expressing their concerns and making demands, opposition from the powerful gun lobby, whose agenda was to derail all anti-gun legislation and who called Rathjen and Cukier "do-gooder feminists". Rathjen quit her job as an engineer and began working full-time on lobbying and public education. They appeared at rallies and faced up to the vocal opposition from the gun lobby. Gun control became an issue during the federal election in 1993; and legislation came into effect on 1 January 1995 which bans 21 types of military and paramilitary rifles and assault pistols, restricts the sale of ammunition to those 18 years of age and older who want to acquire a hand-

gun, quadruples (to four years) the automatic sentence for those who use a weapon in committing a crime such as sexual assault, robbery, kidnapping and attempted murder, and imposes a ban on the sale of hand-guns affecting 58 percent of the 950,000 hand-guns on the market.

Within the Evangelical Lutheran Church in Canada, the women's organization has prepared study materials on male violence using the Montreal massacre as a starting point. The film "After the Massacre", distributed by the National Film Board of Canada, is used with the material. Several Protestant denominations have prepared study guides for those wanting to understand and address violence in our society; and prayers have been written for congregations to use on the anniversary of the massacre.

A newer form of violence against women in Canada is "stalking", in which a man hunts down a particular woman, usually because he is unable to control her and seeks to intimidate her. The case of Terri-Lyn Babb is one such example. In August 1990 she was treated for depression in a hospital in Winnipeg, where she met Ronald Bell, a nurse. The two developed a friendship, and when she was discharged from the hospital he invited her to move into his apartment "as friends". The arrangement lasted less than 24 hours when Bell attempted to move the relationship from platonic to romantic. He had a strong need to control her, and the relationship was characterized by his possessiveness. Babb moved in with her parents and over the next six months avoided all contact with Bell. Frustrated and angry at being spurned, Bell posted papers detailing Babb's psychological and emotional problems on buildings and trees in the neighbourhood and in the hospital where she was treated. Once he jumped out of his car and threw a paper bag at her containing a stuffed animal with the written message "Terri, you're sick". At that point, she filed a complaint with the nursing association and Bell quit his job. Babb continued to live in fear. Friends escorted her to appointments and to college, since Bell was always around and she was afraid to go out alone. Her friends and neighbours all confirmed that she was indeed being stalked. Whenever she went out, whether to work or to socialize, he followed her.

In May 1992 Babb obtained two peace bonds ordering Bell to stay away from her under threat of criminal prosecution. In August 1992 despite his history of psychological problems, Bell was issued a gun permit; and on 21 January 1993, while Terri-Lyn Babb was standing

at a bus stop near the hospital, Ronald Bell approached her from behind and shot her in the back of the head. She died instantly.

At the trial, where Bell was sentenced to life in prison, details of his stalking were revealed. He had kept a diary in which he had recorded his sightings of Terri-Lyn Babb over a number of months, including what she was wearing, whom she was with and where she went.

Since the death of Terri-Lyn Babb, gun control procedures have changed in Canada, largely as a result of pressure from the women's groups and the general public. When Ronald Bell filed for his gun permit he filled out a one-page application; now a four-page application is required, including a photograph and two references from the applicant's spouse, employer, co-worker, clergy, judge, aboriginal chief, police officer or mayor. In addition, the applicant must pass an approved firearms safety course. Moreover, police now have access to a computer network which allows them to determine if the applicant is under a restraining order, separation agreement or other such order. All of this should make it more difficult for people like Ronald Bell to acquire a firearm.

In June 1993 the federal government added the charge of criminal harassment to the criminal code, specifically citing the Babb murder and another similar incident in Manitoba as evidence of the need for such legislation. Women now have legal recourse and police support if they find themselves victims of a stalker. The law prohibits any individual from repeatedly communicating with or following another individual, members of that person's family or anyone known to that person against the person's will. No individual may cause another to fear for their safety or the safety of anyone known to them. The maximum penalty is five years in prison.

These case studies raise questions for both men and women about the future in our changing society. Speculation centres on men's ability or inability to share power and to see new models for living. In noting that both Ronald Bell and Marc Lepine had childhoods marked by abuse and domination, we need to reflect on our own parenting styles and behaviours. Are we rearing children to base their relationships on power and control, or are we fostering respect and compassion that leads to adults who work for and live with justice in mind? What is the role of a nurturing father, who is a co-creator with his wife in all aspects of their life together, in rearing sons to be responsible and balanced men of integrity? We have much to explore as we

continue to create and shape a world in which men and women are mutually respected, valued and given opportunity to contribute to the human family.

NOTES

[1] From the film, "After the Massacre", National Film Board, Canada, 1990.

[2] *Ibid.*

[3] *Ibid.*

[4] *Ibid.*

[5] Cited in *Maclean's*, 18 December 1989, p.19.

[6] *Ibid.*

[7] *Ibid.*, p.18.

[8] *Ibid.*, p.19.

7. Dominican Republic
A Rising Tide of Violence

Both official police reports and stories in the media document a continuing increase in violence against women and girls in the Dominican Republic over the years from 1990 to 1994. According to national police statistics, 95 percent of the victims in cases of abuse reported to them are women and children. A study by Rose Nina of the ministry of health has established that from 1990 to 1992, 64 percent of the cases of aggression against women took the form of murder, 4 percent murder and rape and another 4 percent rape alone. Beatings accounted for 21 percent and attempted murders 3 percent. Most of the aggressors were husbands, lovers or partners of the victims. These figures coincide with the records of the Women's Action Research Centre (CIPAF) for the same period, which also show that most beatings take place during pregnancy. According to a report from one hospital, 21 percent of pregnant women had been beaten, leading to a high number of miscarriages.

Comparing these figures with statistics from 1993 to 1994 reveals a significant increase in only one year. Murders accounted for 67 percent, rape and murder over 12 percent and rape alone 18 percent. Beatings accounted for 25 percent and attempted murders exceeded 6 percent. As in previous years the principal aggressors were the husbands, ex-husbands, concubines or lovers of the victims.

The most recent data available to the CIPAF Documentation Centre draw on criminal charges reported in the national press between November 1993 and October 1994. Sixty-seven accounts of violence against women and girls were compiled, covering 80 cases denounced through various channels, including the police, hospitals and the mass media themselves. During a two-month period alone, in

Espaillat province, especially in Moca, more than 24 women and girls, most of them under 14, were raped and in some cases murdered. Later, the co-ordinator for women's affairs in the region of Cibao drew public attention to the hundreds of cases occurring there, pointing out that most happened within couples. Questioning the response of the police to these charges, the co-ordinator suggested that usually "the murdered women ceased to be victims and were made responsible for their own fate, even at the level of legal process".

Of these 80 cases studied, 24 women were killed by their husbands, ex-husbands, ex-lovers, companions and partners for reasons of "passion". The victims in ten other murder cases were very young women (14-15 years of age), some of them murdered after horrendous sexual abuse. Sexual violence continues to be the main form of aggression by men against women, regardless of age. In addition to being raped, women in the Dominican Republic are being murdered, assaulted, threatened, beaten with all kinds of weapons and even kidnapped.

As far as the victim-perpetrator relationship is concerned, there is no doubt that those most to be feared are the persons nearest to the women by family or affectional ties. Eighty percent of aggressors are men close to the victims, with whom they are living or have shared the same dwelling. Most victims are under 30, the largest number being in the 16-30 bracket.

The motives the print media cite most often to explain the causes of violence against women in relationships are her "not wanting to live with or go back to him" and "a fit of jealousy". Even if the press often does not explicitly report the reason for such acts of violence, the context almost invariably makes it clear that the motive had to do with jealousy or love.

The press never mentions a "cause" or "motive" in cases of sexual abuse and rape of young girls. That is, no explanation of these events is given. In the period studied, these incidents occurred in different regions of the country, the region of Cibao standing out more than in previous years for the number of cases reported there.

It is difficult to establish accurate statistics concerning violence against women nationwide. Although the homicide department within the national police keeps records of all reported cases and accusations, these are not sufficiently well documented. Besides, many of the cases reaching public hospitals and private clinics are never turned over to the police, let alone given any publicity. Accounts appearing in the press are thus very difficult to reconcile with other available statistics.

In March 1994, 63 cases of rape were reported in the National District alone, in which 30 of the victims were minors. In May, the newspaper *La Noticia* reported (citing the sexual offense division of the national police homicide department) that 70 women had been raped in the capital alone and that several of them were as young as four years. According to the same source, during May some 509 persons were being held on charges such as child abuse, rape and murder, the victims being mainly women.

This illustrates the difficulties of comparing different sources. CIPAF thus believes it is important that a department be set up which is responsible for maintaining records in a methodical manner. Such a mechanism could compile and consolidate data from the National Police, public hospitals and private clinics, as well as from other possible sources of denunciation of violence against women in Dominican society.

8. *India*

Reworking Gender Relations, Redefining Politics

ANVESHI COLLECTIVE, HYDERABAD

Over the last decade or so the Indian state of Andhra Pradesh has witnessed a series of struggles, primarily initiated by poor rural women, over the government-backed sale of arrack.[1] The nature of the campaign has given these women a measure of control over their daily lives and transformed their relations with men. Working only within their villages, enforcing the closure of local arrack shops and targeting excise department officials and police, they have also effectively confronted the state and destabilized its economy. In developing unique forms of struggle and resistance, women who have never been involved in politics as traditionally understood have been redefining the meaning of the political. No group or party seems to have provided the movement with an ideological framework or strategic plan. Arrack has become a nodal point enabling the women to comprehend the predicaments they face daily in work, the family economy, health, education and their personal lives.

The flood of liquor

Excise taxes make up a substantial portion of state tax revenues, and arrack has been by far the largest source of excise revenue from liquor sales. Moreover, tax accounts for only one-third of the price of arrack, with the rest going into the coffers of the liquor contractors. The sale of arrack has drained about 2000 million rupees a year from the most disenfranchised of Andhra's citizens.

Varuna Vahini ("the flood of liquor") was launched in the early 1980s by the then-chief minister of the state (who is now trying to benefit politically from the anti-liquor movement, claiming that he favours prohibition). Previously available only in bottles or pots,

arrack began to be distributed in sachets, ostensibly to prevent adulteration, but also much easier to transport and carry home in one's pocket. The auctioning of shops in each village was centralized, with large contractors and coalitions bidding millions of rupees for the right to sell arrack, which was in turn sub-auctioned to smaller agents, who had to pay heavy monthly rentals to the government. To ensure their own profits, these sub-contractors resorted to highly aggressive sales, and the resulting flood of liquor breached village life at many points. For example, it became common for labourers to receive their wages in the form of coupons or tokens to be exchanged for arrack at the village shop. Thus, in return for a day's work, a family received no money, only drunken men.

The movement has had many origins. In one village, the inauguration of a literacy programme, attended by state and district officials, was disrupted by some drunken men. The village women demanded that the arrack shop be closed so they could have their classes in peace. Willing to promise anything to ensure the success of the literacy programme, the officials complied. For many women, it was a personal tragedy that led them into the struggle against arrack, especially when they realized that most other women in the community were having similar experiences. There were numerous incidents in which women have been abused to the point of committing suicide. A variety of experiences, discussions and stories is now being recalled as catalysts for strengthening and spreading the agitation.

Even so, the spread of the movement to 800 villages in a matter of months was remarkable. More than 500 shops were forcibly closed. After being postponed 32 times, auctioning in one district of Andhra Pradesh was finally cancelled. While preventing local liquor shops from functioning by destroying arrack, burning sachets and forcing local sellers to close their shops, the women have resisted pressure tactics and attacks from contractors, excise department officials and excise police. Despite the power-nexus of the government and liquor lobbies, the movement is growing in almost all the districts of Andhra.

A striking aspect of this agitation is how it crystallizes around a range of issues with which the problem of arrack is linked. Women have complained vociferously about their deteriorating economic conditions, which are aggravated when so much of a day's earnings are spent on liquor. Often they refer to other issues while discussing liquor — the expected rise in the price of rice, the absence of

basic amenities like water and health care. Women in a village about 150 km from Nellore drew a graphic contrast between the ease and punctuality of the daily arrival of arrack in their village and the difficulty of getting water, which had to be brought from a distance of 4 km, since there was no local source, or treating a simple case of diarrhoea, which required a trip of 16 km. Women are acutely aware of the gross injustice perpetrated by a government bent on obtaining revenues through the sale of arrack, while providing nothing for the village.

Reconfiguring gender relations

Unexpectedly, the main target of the women's wrath and attacks has been the village arrack shop, not their men. These shops often occupied a distinctly public space, near the village entrance, next to the bus stand and the tea shop.

Men were certainly not viewed as criminals and least of all as immoral. It has been illuminating to catch glimpses of the effects the movement against arrack has had on gender relations. Women were often much more comfortable and confident taking men on in a relatively public space like the arrack shop, where they could act in solidarity as a group. Women have sometimes spoken in detail about their personal lives, not hesitating to describe the lengths to which they would go to beat up drunken husbands or subject them to public ridicule if necessary. Other women felt nervous, even helpless, about their personal relations with their husbands, especially the personal shame at moments of being abused. The difficulties of tackling private relationships are very real, compared with collective forms of confronting men.

Though some overt hostility might be expected from the men, they are often passive supporters of the movement. A visiting team from Anveshi in Hyderabad, who had gone to Nellore District to learn about the anti-arrack movement, noticed that in the meetings they held women clearly had the upper hand, at times beckoning men to come forward, singling out those who used to drink. The men would respond with a mixture of sheepishness and nervous laughter, often acknowledging how much they had benefited from the campaign. Replying to a question about how men regarded a movement so clearly initiated by women, one man shamefacedly tried to argue that in fact the men had given the women the opportunity, "otherwise they would not have been able to succeed".

The village as locus of politics

The women involved in this struggle often seem to have decided consciously to centre their efforts within their own village in order to retain control over the situation. The popular slogan "We don't want liquor in our village" symbolizes the struggle. Those who believe that the only way to strengthen the movement is by taking it to higher levels must consider that one implication of doing so may be to take control of it out of the women's hands.

Intentionally or not, an extremely interesting outcome of the struggle is that there is no central leadership. With women independently taking up local agitation and initiatives in their own villages, the movement is truly dispersed, creating some anxieties for political parties, but even greater frustration for the state, which is thus unable to curtail the movement by arresting key organizers.

The demand for the banning of arrack sales in fact accords with the directive principles of state policy enshrined in the Indian constitution. On the one hand, therefore, the state is duty-bound not to dismiss the women's demands, while on the other hand its own existence has become increasingly dependent on the revenue from liquor. Rather than directly taking on the state, women have managed to upset its power by severing the nexus between the government and the liquor contractors where it functions most effectively — the arrack shop, the stock points and the auctions.

The state government set up a committee to assess public opinion regarding a proposed ban on arrack. Whatever the contents or effects of this report, there is little doubt about the state's desire to cripple the movement itself. Among the more underhanded methods adopted to break women's morale has been to float the rumour in a number of villages that if women succeed in stopping arrack sales, the price of rice will promptly be raised.

What has most disheartened women in many places where auctions have stopped is that excise department officials, with the connivance of the police, are now actively pushing illegal arrack. Women have expressed confusion and anguish over the degree to which the state is forcing arrack into the villages. "Let them sell openly during the day in the shops — we can take care of that. How can they smuggle it in secretly, in milk cans and chili baskets? Let them kill us women and children and take care of the men with *saara* [arrack]." If the perceptions of the women are taken seriously, more attention is needed to the criminality of the government's excise

departments, who are resorting to all kinds of methods to continue to supply liquor to villages where sales have been stopped.

What does such a genuine and spontaneous social movement imply for the women's movement in India? Is the agitation against arrack yet another phase of women's ongoing struggles against patriarchy, as these struggles have hitherto been analyzed, or is it to be understood differently?

Women in this case do not appear to be particularly concerned with tackling gender relations directly. For instance, when the representatives of the movement shared with a visiting team a list of issues they had prepared for the literacy programme, women's problems figured prominently, along with matters related to the economy, health, environment and caste. Arrack came at the very end. Yet the women chose to take up not the issues marked higher on the list but arrack instead.

While a movement such as this does not exemplify conceptions of feminism in any simple way, feminist issues nevertheless crop up everywhere. We only need to remind ourselves of some of the methods women have brought to bear in the course of the agitation: attacking contractors and excise department officials with household "weapons" like brooms and chili powder, refusing to cook or eat, publicly shaming their men. In the face of the complex, innovative and confusing configurations of gender and politics in this movement, it is a challenge to reflect more carefully on the extraordinary forms of action demonstrated by rural women in Andhra in the process of empowerment by calling to account the most oppressive structures controlling their lives.

NOTE

[1] Arrack is a locally brewed alcoholic drink, sold by the government in legal outlets. This case study is based on an article about the visit to Nellore District of Andhra Pradesh by a team from Anveshi in Hyderabad; *Economic and Political Weekly* (Bombay), 16-23 January 1993.

9. Kenya
Mothers in Action

JOYCE K. UMBIMA

Mothers in Action, a pressure group unaffiliated with any political party, was formed spontaneously in response to the tragic mass murder and rape at St Kizito Secondary School in Meru, Kenya, on 13 July 1991, in which 19 girls died, 71 were raped and over 100 others were physically, psychologically and emotionally traumatized.

Those who founded Mothers in Action vowed to work, lobby, raise awareness and seek support from others to ensure that no such tragedy should ever again happen in Kenya. Members of the group themselves financed the first of the educational materials it developed — on confidence-building and self-defence for women and girls. They also reached out immediately to the victims, offering sympathy, understanding and solidarity with the girls in the spirit of womanhood. Through the headmistress, personal letters were written to each of the girls offering support for those who needed help and informing them where they could get it.

The response to our letter shocked us into recognizing the magnitude of the trauma the girls were going through. They were frightened, very confused and haunted by feelings of abandonment. They had received no counselling; and when the government subsequently closed St Kizito school, it created new financial hardships for the girls and exposed them to a hostile environment without the necessary support mechanisms.

Given the magnitude of the problem, Mothers in Action had to set priorities in order to respond to the most urgent need — which was identified as reaching out with counselling and moral support to the 66 girls who were due to take their final examinations and subsequently leave school in November of that year. It was not easy to identify a

donor who would acknowledge this as an urgent and critical concern, but UNICEF's country office finally made a small grant which enabled Mothers in Action to arrange for professional counselling and medical examinations and to produce back-up materials for the seminar.

Continued support of all the girls who were at St Kizito remained a priority on the agenda of Mothers in Action throughout 1992. Seminars and counselling sessions were offered to the girls who remained in school, and there was follow-up with the girls who had left school and their communities.

Political change in Kenya

In December 1991 it was announced that Kenya had embarked on a path of political pluralism. Clearly, the dawn of multi-party politics would bring positive changes to the situation in Kenya. Although in a one-party state political participation is not meaningful for either men or women, its effects on women are especially negative.

> For women the limitations are even more severe, since men dominate the bureaucracy at all levels, the military, the central executive of the party, the directorships of parastatals, etc.; and they rely on the substantive educational, status and experiential advantages that they have established and an ideological patriarchal dominance to sustain that control. [1]

Mothers in Action, like other women's groups, expressed concern that the new political processes in the country might continue to marginalize women. Women's issues were still regarded only as those pertaining to the integration of women into development. Presenting its position at a seminar in January 1992, Mothers in Action stated:

> Whereas development is, and will continue to be, important there can be no development without participation, and participation is democracy. In the past women's development efforts focused on the integration of women in development, a development which is already unequal and which has marginalized women. We now recognize that true development is about power, and power is politics, and therefore for us to develop we must be in the centre of politics.

Recognizing that every human is political, Mothers in Action asserted that women can no longer afford to be apolitical within the family, in the community or at the national level, and declared its

intent to ensure that women's concerns became an integral part of the mainstream of the ongoing political processes.

Among issues to which women must pay special attention are:

Political empowerment. There is a great need for women to penetrate into all spheres of public life, in particular parliament and local authorities, if they are to advance their agendas for change. A brochure was prepared on "Kenyan Women in the Democratization Process" and was translated into Kiswahili.

Economic empowerment. Women need to address the value of their work, including their participation in agriculture and in alternative economic activities. They need to look critically at such issues as women as consumers, access to credit, the bread-winner concept and hawking in the streets of Nairobi — all against the background of international debt restructuring and the economic status of women.

Violence against women. Two brochures on the subject developed by Mothers in Action are being translated into Kiswahili and used in workshops.

Voter education. Mothers in Action worked with the Kenyan Women's Voters League to identify areas of special concern to women: location of registration centres, the issue of identity cards, vote-buying, female political representation and participation and women's responsibilities and rights as voters, candidates and citizens.

Women and law. The Marriage Bill needs to be discussed by women before presentation to parliament. Issues such as the custody of children, property rights, dowry, polygamy and inheritance also affect women in a specific manner in case of divorce, separation or death.

Solidarity among women. Because women must work together in pursuit of their common interests, Mothers in Action emphasizes networking among women to raise awareness of the need for mutual support. The National Convention for Women has been identified as a forum for enhancing and encouraging the work of women on a common agenda.

Goals, objectives and strategies

An overall goal of Mothers in Action was to ensure the implementation of the international Convention on the Elimination of All Forms of Discrimination Against Women as a means of improving the status of Kenyan women.

Several long-term objectives were identified:
— to educate and inform the public on gender discrimination, both the issues involved and the value and benefits of eliminating all forms of it;
— to create awareness of all forms of violence against women and girls and to advocate and spearhead actions to fight it;
— to promote networking between advocacy groups and organizations in order to strengthen their advocacy and ensure that it has an impact on changing negative attitudes, practices and behaviour towards women and girls;
— to provide support to victims of violence, abuse and other forms of discrimination, especially to women and girls;
— to intervene in processes critical to the improvement of the status of women and girls, especially the democratization process, by providing technical, material and moral support;
— to provide for discussion, review, planning and monitoring of the improvement of the status of women in Kenya;
— to advocate for the representation of women at all levels of decision-making and educate the public on matters relating to good governance, including popular participation;
— to build solidarity among women and men in fighting gender discrimination and other social evils, and in promoting democratic processes in decision-making at all levels;
— to promote participation of young women in the Mothers in Action movement and in the fight against all forms of violence, abuse and discrimination against women and girls;
— to strengthen Mothers in Action as an institution so it can implement its long-and short-term objectives.
Among these short-term objectives were the following:
— to support the victims of the St Kizito tragedy by providing moral, psychological, medical and material help and counselling through correspondence, visits, workshops, donations, sponsorship and medical services;
— to educate the public on issues relating to the improvement of the status of Kenyan women and the elimination of gender discrimination;
— to participate in efforts to increase the number of women candidates for civic and parliamentary seats, encourage the public to support gender-sensitive women and men candidates and educate voters on their rights;

— to undertake a public education campaign through the publication of brochures, issue papers, stickers, posters and other materials on issues and concerns of women and girls;

— to collaborate with other advocacy groups to intensify the campaign for the recognition of the importance of gender issues in the democratization process and to mobilize women in rural and urban areas to adopt a common stand on our issues.

Achieving this objective required an intensive programme of mobilization, advocacy, networking and provision of education to women and men in rural and urban areas. At the same time, it was the intent of Mothers in Action to share with all political parties its agenda and its views on democratization, in order to articulate Kenyan women's place in the process and induce the parties to incorporate these issues in their own constitutions, manifestos and plans of action.

A National Convention, which sought to create a critical mass of Kenyan women to share concerns and develop a common position on key issues, brought together more than 2000 people from all parts of the country. Its specific objectives were to:

— mobilize and bring together women leaders from all over Kenya to discuss their role and participation in the democratization process;

— share key issues and concerns that must form the agenda of women in the democratization process and in Kenya's future development;

— enlist the commitment of the participants to sharing issues and concerns with women at district and other levels;

— advocate support for women and men candidates who are sensitive and responsive to gender and other human rights issues;

— start identifying potential women candidates for civic, parliamentary and other leadership positions;

— build the solidarity and common purpose of Kenyan women in the democratization process.

The Convention was organized jointly by Mothers in Action, National Council of Women in Kenya (NCWK), Africa Association for Women in Research and Development (AAWORD), Kenyan Women Voters Leagues and other lobby groups. It was funded through a *harambee* effort by Friedrich Ebert Foundation, Catholic Relief Services (CRS) and contributions from the organizing agencies.

The participants in the Convention were invited through the mass media, the organizing agencies, religious bodies and lobbying groups. An effort was made to broaden the base of representation by encourag-

ing the participation of young women and potential women leaders who have hitherto been unknown and unrecognized.

English and Swahili were used as Convention languages with materials on key issues in both languages and simultaneous interpretation facilitating free communication by all. Presentations were very brief and intended to provoke and start up discussions and contributions from participants.

As a follow-up to the National Convention, district workshops were organized with similar objectives, content, process and methodology. While Mothers in Action and the other advocacy groups provide resource persons and materials, the district leaders must mobilize, organize and provide leadership for activities at the district and lower levels.

A third element of the strategy was a public education programme on the status and situation of women and girls in order to ensure that these issues were central in the process of democratization, to persuade women and men voters of the value of their vote and to urge the election of only gender-sensitive candidates. The long-term objective was to sustain and expand the programme beyond the election, increasing advocacy for the improvement of the status of women, continuing the campaign on the elimination of all forms of discrimination against women and offering ongoing support to victims of violence.

Production of educational materials began in July 1991. Six brochures in English were translated into Swahili for distribution at the National Convention. These materials have been developed by members of Mothers in Action on a voluntary basis, working in committees or in small groups.

Alongside the public education programme, Mothers in Action maintained its counselling, support and educational activities with the girls of the former St Kizito School, and maintained its advocacy activities to fight violence against women and girls.

The hope is that this can restore the confidence and self-worth of these victims. At the same time, materials can be generated for the support and counselling of other victims of violence, stronger links can be forged among schools, teachers and girls, more young women may be brought into the campaign against violence, and members of Mothers in Action can increase its skills in dealing with violence against women.

* * *

The Mothers in Action programme was monitored to ensure the achievement of its objectives and proper use of resources. Reports were made on every activity, and materials were made available to collaborators.

As Mothers in Action became stronger, however, it became a threat to some powerful sectors in society. Soon it was being labelled as *political*. Women who were members began to be described as "disgruntled elements" and were threatened in some cases even by their own families. Consequently, the group began to fall apart, and now only a skeleton of it remains in existence.

NOTE

[1] D. Hirschmann, "Women and Political Participation in Africa", *World Development*, Dec. 1991.

10. *Namibia*
Women's Solidarity

GISELLA HAOSES

Women's Solidarity is a non-governmental organization in Windhoek, Namibia, engaged in counselling and support, education and research on violence against women. Membership is open to anyone who can regularly attend our weekly meetings. At present we have 16 active members, all of them volunteers except for one part-time paid worker.

Women's Solidarity was formed in early 1989 under the name Rape Crisis by a group of women who wanted to assist women victims of violence both directly through counselling and support and indirectly by raising the level of awareness and information in Namibian society about how violence against women is manifested, its causes and effects and what can be done to stop it.

Over the course of time, our primary concern has shifted from counselling to education and consciousness-raising. We act as a pressure group on the issue of violence against women, for example, by making sure that it is on the agenda wherever women's rights are discussed, by making proposals to the Namibian government for reform of laws concerning rape and by putting pressure on the police to intervene in cases of domestic violence.

Women's Solidarity offers talks, workshops and seminars to any interested party. We have done educational work in a number of local schools as well as with women's groups, church groups, the Namibian police and other professional people who come into contact with survivors of violence. With this last group, our focus has been on sensitizing them to avoid "secondary victimization" in their encounters with women who have been assaulted or raped by blaming the woman herself for what happened to her. We have also participated in

many radio and television programmes in the hope of changing the prevalent victim-blaming attitudes in the general public towards women who experience violence.

While our support is available to any woman who has been raped or sexually, physically or emotionally abused, we will do so only with women who approach us themselves, not through a third party. Counselling may be over the telephone or face-to-face, depending on what the individual woman requests. With face-to-face counselling, Women's Solidarity will offer to meet wherever the woman feels *safe* and comfortable. Counselling may be a one-off session or may continue over a period of time, again depending on the wishes of the woman.

Telephone counselling is usually a one-off session and often focusses on practical legal and medical advice to empower the caller to cope with immediate problems. Each of our two telephone lines is connected to an answering machine, so that if no one is available when a woman calls, she can leave her name and telephone number. Women's Solidarity also has an office where women are welcome to visit our community worker for advice and support. The attempt is to create a space in which women can freely express and explore their feelings. At present we can offer counselling in English, Afrikaans, Damara/Nama, German and Oshiwambo.

The aim of our support work is to empower women, through practical help, to cope with their situation and take control of their lives. We do not blame women for their situation, and we try to make women realize that they are not guilty for what has happened, whether it is rape or a case of repeated domestic violence.

Women's Solidarity has also carried out research to determine what legal reforms are needed in Namibia regarding the punishment of convicted rapists in Namibia and the provision of shelters elsewhere in southern Africa for women who need a place of safety.

A leaflet distributed to acquaint affected women with the services Women's Solidarity offers illustrates this practical approach. Here are some excerpts from the text:

Women's Solidarity is a group of women who have come together in order to fight the problem of violence against women in our society.

Women's Solidarity offers support and advice to women who have been raped or beaten. If you have been raped, beaten or sexually assaulted and would like to talk to somebody, you can contact us... at any time.

Talking to another woman about your feelings and experiences may help you to feel better about yourself. Women's Solidarity will offer you legal and medical advice and help you with practical problems.

Women's Solidarity also holds educational workshops and gives talks to the public in order to raise awareness about violence against women in our community.

Women's Solidarity offers counselling and advice to women who have been raped, beaten or sexually assaulted. You can call at any time as we have a 24-hour answering machine and we will contact you as soon as possible...

Rape

We believe a person is raped whenever she/he is forced to have sexual intercourse with a man without wanting to — whether or not physical violence is used.

Rape happens without a woman's consent and against her will

Women's Solidarity believes that rape is a crime of violence not a crime of passion.

Who is raped?

Rape can happen to anyone. Violence against women is increasing in Namibia. Children as young as six months and women as old as 93 years have been raped. It makes no difference what you look like or what you are wearing.

No woman asks to be raped

How does rape happen?

A rapist doesn't always use guns or knives to force a woman to have sex with him. He may scare her with words and by being physically stronger. Rape can happen at any time of the day or night, and most rapes occur in the home.

Who are the rapists?

Most rapists are ordinary men leading ordinary lives. Many are married or have steady lovers. Many rapists know the woman they rape. He may be a friend, a boss, a boyfriend or a family member. These are the rapes we seldom hear about. Only one out of twenty rapes is reported to the police.

Why do men rape?

Rape is an act of violence and not an act of lust or passion. The rapist wants to show how powerful he is and uses sex as a weapon to do this. Most rapes are planned beforehand. The rapist may rape to prove what a tough man he is; he often feels angry towards women and may want to make the woman feel like dirt and to hurt or punish her. This is not the woman's fault.

No woman wants to be raped and no woman deserves to be raped

What happens after you are raped?

If you are raped you may wonder what you did to bring on the attack; you may feel ashamed and blame yourself. But it is important to remember that no matter what you did, no one has the right to rape you. It is the rapist who is responsible for the rape, not you.

Women may feel a lot of different things after being raped. You may feel depressed, dirty or afraid. You may feel angry, used or numb. It may be difficult to talk about it, and often there is no one you feel will understand you. Many women never talk about being raped and keep it to themselves their whole lives, not knowing there are many other women who feel the same way.

What to do if you are raped?

We all need different things and feel differently, but here are some things you may wish to do if you have been raped:

— go to a place where you feel safe;
— find someone you can trust to talk to about what has happened and how you feel;
— see a doctor about injuries and to check against sexually transmitted diseases and possible pregnancy;
— decide whether you want to report the rape to the police. You will have to have a medical examination, re-tell the story in detail and possibly attend court hearings. If you are pregnant from the rape you have to report it to the police in order to get a legal abortion;
— you can call Women's Solidarity for counselling and advice, support and caring.

Battering

When a woman is beaten or hurt, physically or emotionally, by her partner, she is a battered woman. Many men believe that they have the

right to control their wives, children or lovers, and they do this by beating them.

Women's Solidarity believes that no one has the right to hurt those close to us and that women who are battered should be given the opportunity to change their lives and live free of their violent partners.

What can you do if you are a battered woman?

Contact Women's Solidarity — we offer support and confidential counselling from someone you can talk to. We also offer legal and medical advice.

You can get a lot of help and feel stronger if you talk to other women about your problem. There are many women in our community who are beaten by their men. If every woman who is beaten spoke up about it, the strength of women's voices would force people to take notice of the seriousness of battering.

How can the law help you?

If you are hit by your husband or lover there are a few things you can do:
— get a peace order or an interdict to stop him from hitting you;
— lay a charge for assault against him at the police station;
— you may want to end the relationship, in which case you may think about divorce.

11. Nepal

Devaki — Socio-Cultural Violence Against Women

MEENA POUDEL

Violence against women takes various forms in Nepal, where a male-dominated society has created many cultural and social excuses, familial and caste traditions, religious and ethical customs to oppress and exploit women.

One such type of violence is *Devaki*, a custom prevalent in the far western region of Nepal. While there is no definite evidence regarding its origins, the story is that during the period before the many small principalities in this region were unified into Nepal in 1768, the local god was once unhappy with one of the kings. In his wrath, he subjected that kingdom to famine and various other kinds of havoc. The king tried to assuage the anger of the god and rescue his people from the curse by offering his own daughter to serve the temple. Offering a girl to appease the god's wrath subsequently became a custom whenever people fell into some kind of misfortune or trouble.

It is believed that the god is pleased if the girl (*devaki*) is offered before menstruation, so usually the girls offered are between 7 and 10 years old. They are supposed to maintain the cleanliness of the temple and conserve its physical surroundings, protect property and take care of regular worshippers and visitors.

Today people continue to practise this custom of seeking to make the god happy. Some may be seeking relief from epidemic diseases. Or a childless couple may wish to have a baby. But whereas originally those seeking to appease the god originally had to offer their own daughter (unless they had no daughter, in which case they could adopt someone else's daughter) rich people today buy a girl from a poor family, adopt her as a "daughter" and then offer her to the temple. The custom has degenerated to the point that wealthy and powerful people

buy and offer girls from poor families just to show off their power or wealth.

Thus these days only girls from poor and oppressed families are bought and offered as *devaki*. Often the sale takes place at a stage when they do not even realize what is happening. Nobody tells them about their fate; and usually even after the offering they may stay living with their own family. Only when they come of age do they learn that they have been sold in the name of the god. Once offered as *devaki* they cannot marry or have a family life, for people believe that a man who marries a *devaki* will die a violent death. Not only that, he will become an outcast from the community as well. However, the society, community and families do not object to men having sexual relationships with *devaki* as kept women or prostitutes. Thus government officials working in remote villages often use *devaki* as kept women to fulfil their sexual desires, leaving them behind when they are transferred. Any children born as a result become the property of the temple as well. If a boy is born he becomes a slave of the temple; if a girl is born she too becomes *devaki*.

The *devaki* custom thus exploits women of those areas in two ways. First, because of widespread poverty, girls may be sold at any time as required by rich and influential people of the area. Second, they lose their rights to marry and live a family life, and at the same time children born from them also become nobody's responsibility. If poor parents decide not to sell their daughters when asked by the rich people and landlords, they will face a very difficult life — not being hired as wage labourers and perhaps being taken to court or to the police under false accusations.

While this type of abominable and inhuman socio-cultural violence against women's rights continues, the so-called democratic government turns a blind eye, as if the human rights of the victims can be safeguarded by remaining silent when they are victimized.

Women Acting Together for Change (WATCH)

To confront the issue of women violated by the sex trade in Nepal, WATCH is working from three different angles:

First, WATCH is seeking to make people around the country aware of this situation and to mobilize the general public to stop this crime. This effort is carried out through local women's groups and in schools and on campuses. WATCH has been able to give training in

30 schools and on two campuses and has enabled more than 50 local NGOs to initiate similar activities in their own areas.

A second dimension, on which we spend most of our time, is lobbying and advocacy with policy-makers and politicians to ensure enforcement of existing laws which ban trafficking in and violence against women, as well as the formulation of effective new laws in this area. Social rejection is very high once a woman is trafficked, and local media play a very negative role in her rejection. Advocacy to sensitize the media as well as the local community to respect her human rights is thus crucial.

The third and most important task is to find alternatives for women who are coming back from sexual slavery. WATCH provides shelter for returning women where they can receive some skill training and counselling, engage in income-generating activities and have their medical needs attended to. Some are offered jobs within WATCH. Since the few returning women who are accepted back by their families seldom have any economic prospects, WATCH is assisting them in community-based support programmes. Not only are they provided shelter, but we are also mobilizing them for advocacy and campaigning against this crime in areas where trafficking is very common.

12. The Netherlands
Nonviolence and Social Defence

SHELLEY ANDERSON

Five members of Women for Peace (*Vrouwen voor Vrede*), a grassroots movement of some 3000 women in the Netherlands, have formed a national work group on nonviolence called the "Social Defence Group". Believing that the world must change if it is to survive, these women — Mira Blankevoort, Herma Ruigrok, An van Sabben, Wineke Ettema and Lineke Schakenbos — are searching for ways to help create nonviolent change, especially by replacing the idea of military defence with creative nonviolent solutions to conflict.

Five stories

Every woman has a story, but ordinary women's stories of nonviolent resistance are seldom told. Mira Blankevoort, who has worked with Women for Peace for more than ten years, collects women's stories. "Our whole history has been written for men," she says, "and it highlights violence and war. So it is important to tell stories about how women have found nonviolent solutions to problems. Such stories give us inspiration, and new ways of learning how to manage violence."

The subjects of Mira's stories include the Mothers of the Plaza de Mayo of Argentina, who helped to topple a dictatorship by regularly gathering in public to demand to know what had happened to their disappeared children. They include the German wives of Jewish men who gathered in front of the jail in Rosenstrasse, Berlin, in 1943, where their husbands were imprisoned. Some 5000 women screamed and cried and demanded until the Gestapo, unnerved by the unexpected protest, released the prisoners.

Mira also tells her own story. At 19 when she received the first wages from her first job, she was so happy that she decided to buy cream cakes to share with her family and friends. The streets of the town were crowded, and she took a deserted road back home. A man appeared and forced her to stop her bicycle. She immediately took out one of her cream cakes and gave it to him. He was so surprised that he made no move when she got back on her bicycle and rode away.

Herma Ruigrok is 64. She has reared one daughter and three sons and is now a grandmother. Two of her sons became conscientious objectors. "It is very important to rear our children nonviolently, to counter the common idea that you have to have power, that you always have to defend yourself," Herma says. "I taught my children to trust themselves and others and to have respect for others. People warned me that they would become victims, but they were never afraid of bullies. They felt secure in themselves."

During the 1980s, when peace groups in Europe were popular, Herma taught a course on nonviolent parenting at local schools. Now, she says, "times have changed and teachers' interests have moved on to other things. But I hope that more people will come to trust in nonviolence and see that people can work together without violence."

She developed her own belief in nonviolence after surviving the second world war. Among other things this has led her to support the Dutch war tax resistance movement, a campaign to encourage people to withhold the 10 percent of their taxes that goes to the military. Efforts to change the law so that taxpayers can legally designate that percentage of their taxes for a peace fund have not yet succeeded, although Herma says many voters are enthusiastic about the idea.

An van Sabben has worked with Women for Peace for more than ten years. She too was drawn to the commitment for nonviolence by her experiences during the second world war, when she cared for wounded men. "I saw so many German young men, farmers and ordinary people, who had no idea what they were fighting for," she recalls. "Some of them thought they were fighting to free us from England. That opened my eyes. War is not the way to solve conflict."

Along with some other women from Women for Peace and people in other Dutch peace groups, An has been involved in peace efforts in the former Yugoslavia. Money has been collected to buy computers and telefax machines for an anti-war centre in Belgrade, to help nonviolence trainers working with peace activists in Serbia and

Croatia, and to support Dutch humanitarian groups providing aid in refugee camps. For people in the village of Pakrac, near Osijek, where Serbians and Croatians have tried to work together, An and her colleagues have collected seeds and 400 pairs of shoes, in addition to supporting work to help refugees learn nonviolent ways of solving conflicts. An believes that the steadfast commitment to nonviolence of peace groups within the former Yugoslavia, despite all that has happened to them, can teach others a great deal.

Conflicts often arise because of economic reasons, she says, and "people all over the world must be educated about the roots of war". Women must work together to change the conditions that spawn wars, particularly, according to An, "because we have so much to do with men in our families, with husbands and sons. We must discuss these issues with them."

Wineke Ettema, a 36-year old mother of four young children, is a yoga instructor. The first *yama* (value) in yoga is nonviolence; and Women for Peace follow this rule in all their activities. During the national days of Women for Peace, Wineke has used yoga to help women to make contact with their own strength, so that they learn to listen both to their own inner voice and to other people. Those who are in contact with their inner strength need not depend on others or be confrontational, so they are able to listen and communicate. This is essential in preventing violence and in mediation following violence. It is also helpful in working for the prevention of racism and in responding nonviolently to it.

After hearing many people talk about their pervasive fears in everyday life, the tense situations one faces while shopping or travelling to and from work, Lineke Schakenbos decided to offer a workshop on this at the annual gathering of Women for Peace in 1993.

"We were surprised that so many women came," she says. "We role-played situations, like a man smoking in a non-smoking compartment on the train, or someone cursing, and then we encouraged the women to use humour and creativity to change the situation. The women became assertive, not aggressive — no one shouted or shamed or blamed anyone — but we tried to make human contact and to say directly what the person was doing wrong."

The inspiration for this workshop came from a story Lineke heard about a group of elderly German women who rode the buses in Berlin carrying heavy luggage. Whenever they would see a young man harassing someone else on the bus, they would come up to him and

ask politely if he would help them with their luggage. And the boys immediately changed and began to help them.

Lineke is also committed to international networking. For many years she has been involved with the War Resisters' International Women's Working Group, which she says "has been a great inspiration to us. We also keep in contact with many women and men involved in social defence, not only activists but researchers too. When we started, we were very inspired by the Mothers of the Plaza de Mayo. We organized solidarity walks in The Hague, wearing white scarves like theirs. It shows how a small group of women who start to protest injustice can grow and grow and inspire many others in different countries."

"Women in many awful situations have found a power inside themselves," Lineke says. "Together they have built a place where women can heal. Nonviolence may need a long time, but it does work."

On the way to nonviolent changes

A brochure which Women for Peace distributes to local women's groups lists ten steps on the way to nonviolent changes, noting that nonviolence calls for dedication, time and money and involves a continuous search for new and creative methods. There are no tailor-made answers for violent situations, but Women for Peace has found these areas helpful:

1. *Inspiration.* The members of Women for Peace have been inspired by women and men, well-known and unknown, who have chosen to work nonviolently for a more just society. These experiences can be passed on to other women and groups.

2. *Getting loose from experienced violence.* Many women have suffered violence as they were growing up. This caused certain painful patterns. Women for Peace are experienced in working with groups and women who want to look at their own socialization in terms of violence so they can take steps in the direction of nonviolence.

3. *Not passing on violence.* Being passive in violent situations passes on violence. Women for Peace are looking for ways to handle situations differently. Everything starts in finding back one's inner strength. From that starting point one can make the right choices for the circumstances.

4. *Nonviolent education.* Nonviolence can be an enriching strength, which mothers can model and pass on to their children.

Women for Peace includes grandmothers and mothers who have practical and theoretical experience in education at home and at school.

5. *Nonviolent conflict-solving.* Conflicts not only occur at home and on the job but even in women's peace groups. Women for Peace offers training in the theory of nonviolent conflict solving and maintains a list of names and addresses of mediators for groups in a conflict situation.

6. *International contact.* Encouraged by the ways in which people in many different countries are working nonviolently to improve unjust circumstances, Women for Peace pass on recent and historical experiences from around the world. Close ties are maintained with the women's group of the War Resisters International (WRI) to share information about women worldwide.

7. *Social defence.* When Women for Peace began, the Dutch government was exploring the possibilities of replacing military defence by a nonviolent social defence. After the government discontinued this, other researchers and activists picked it up; and Women for Peace is available to discuss this with groups. Additionally, they have organized a campaign in favour of legislation to permit taxpayers to designate for peace work that part of their taxes which would otherwise go to defence.

8. *Public theatre.* Since many people experience the street, the city, the tram and the train as unsafe, Women for Peace are exploring public theatre and role-playing as means of helping women to find creative ways to change unsafe public situations.

9. *Current conflicts.* During the Gulf war and subsequently during the war in the former Yugoslavia, Women for Peace and its members have been engaged in nonviolent activities for peace. One of these has involved support for independent media within the former Yugoslavia to try to inform people there about the war so that they will be motivated to work to stop it. People need to be educated to see how persons and communities of different origins must live together now and later. Other ongoing activities include "preventive nonviolence", such as screening textbooks for ideas that promote hatred and war. Women for Peace also cooperates with other women's groups in the struggle against racism.

10. *Cooperation and referral.* Women for Peace works with a variety of Dutch peace groups and communities, as well as foreign groups.

Getting loose from experienced violence

Based on her own practical experience working with women in and after violent situations, Mira Blankevoort has developed a five-step approach for use in two one-day workshops with groups of up to twelve women. The objective is for participants to consider how they have managed to survive their own experiences of violence and oppression. What forces did they make use of? Is it possible to provide a link with social defence?

By way of introduction the following is said:

> In case of social defence you defend something that you set great store by, without using violence. In your personal life you have also gained experience with violence and nonviolence...
>
> In our society there is a lot of violence, conflicts in all kinds of areas. We as women also meet with conflict situations and violence in our socialization. In this we develop certain patterns. Typically feminine patterns are being considerate and caring for others, leading a derived kind of life, not taking any initiatives, developing "feminine" standards and values, avoiding conflict situations, hushing up. This is what you have learned, and lots of it you have swallowed. You have suppressed yourself. You have reconciled yourself to the situation. You feel dissatisfied.
>
> First of all, you have to recognize these unavoidable situations for what they really are: forms of violence. Just try to work out for yourself to what extent you have brought violence on yourself, or are still causing it. What part of you do you really hate? What are you pushing away by the use of violence?
>
> Beside this violence in yourself you might have experienced violence from outside sources as well. Perhaps you were beaten once; perhaps you were not allowed to continue with your studies because you were a girl. How have you always managed to survive? By always looking after other people, by nagging, by suppressing your feelings...?
>
> If you become aware of this violence in your life, if you work on it, if you talk about it, then you will discover the existence of a collective force that makes you strong and changes you. This is a long process you are going through. Later, you can take the next steps, together with women and men and on different levels in our society.

This introduction is followed by five steps:

1. Talking in pairs about questions such as: "How was your childhood? Did you experience any violence or oppression at home? in your neighbourhood? at school?"

2. Talking in plenary session about this conversation (the process, not the contents).

3. Considering privately if you survived the situation of violence or oppression, what survival strategies you applied, how you utilized your strength, who helped you.

4. Reconvening as a group to draw up some statements of affairs, listing them on large sheets of paper, emphasizing the strengths being used.

5. Finding out if there are any links here with your life now, with peace efforts and with social defence.

13. Papua New Guinea
Violence Against Women and Tradition

JUDY TOWANDONG

Violence against women is a daily occurrence in Papua New Guinea. We hear of it from the mass media and we may witness it in our neighbourhoods and on the streets. The growth of this problem is an area of concern for the authorities of Papua New Guinea.

This paper will explore some of the sources of violence against women and the factors that contribute to its regular occurrence in Papua New Guinea, as well as the steps being taken by the state and the churches to combat it and our current needs in fighting this crime. The discussion in this paper looks at two different forms of violence against women: physical violence and discriminatory decision-making in the provision and fostering of opportunities for the two sexes.

Traditional perception of women

In traditional Papua New Guinea society, women were regarded as unclean and dangerous by their very nature. Their monthly periods were believed to be especially dangerous for men; thus they were segregated from men during this time. Men regarded women not as equal partners but as servants, and expected them to be humble, patient, obedient and hard-working. The men were to make the decisions and the women were to implement them. Men could not tolerate women who questioned their decisions or disobeyed them. A woman was never allowed to play a man's role. It was an accepted value that a husband might physically cause bodily injury to his wife in the name of disciplining her to remain in her place.

This clear division of labour between the two sexes is still operative in the villages and rural communities of Papua New Guinea, where eighty percent of the population of 4 million lives. Moreover,

as many as 95 percent of the people living and working in the urban centres today were born and grew up in those villages, where their fathers and mothers taught them such values and norms, which thus retain a great deal of influence in their decision-making styles, particularly in relation to the treatment of their wives, daughters and women in general.

Traditional values and norms, as well as the Judaeo-Christian tradition which we have inherited with the coming of Christianity, have had a big impact on how men view women and define their role in Papua New Guinean society. This I believe will not change for a long time to come.

Alcohol and drugs

Alcohol and drugs are the two important contributing factors to the increase in violence against women and children in Papua New Guinea today.

Alcohol-related violence against women and children is on the rise. Since it was established, the Social Concerns Office of the Evangelical Lutheran Church has dealt with this problem. Women visit the office almost every day to complain that their husbands have beaten them up after consuming alcohol. We have seen women with black eyes, broken arms and knife wounds, and sometimes bury women who have died as a result of this.

Drugs, particularly marijuana, have been in the country for some fifteen years. People grow them in large quantities for sale to youth in the streets. Our young people are growing up taking this drug and many of them are hooked. The people who take drugs are creating more social problems in our communities. Rape, physical attacks, hold-ups and robberies and related problems are on the rise. These episodes are perpetrated by men who have taken drugs, and women and children are often the victims.

If serious steps are not taken now to address the drug issue in Papua New Guinea, much greater problems lie ahead of us.

Current situation

The constitution of Papua New Guinea clearly sets forth the ideal of "active and equal participation of women" in all areas of the country's development as one of the national values and directive principles. Attempts are being made to provide opportunities for women to participate in social, economic, political and religious

development. There is no law restricting the freedom of women to participate actively in those areas.

Moreover, to promote the constitutional value of equal and active participation of women in developmental activities, the state has set up national and provincial councils of women. National and provincial governments make funds available in their annual budgets to support these women's groups, although many of these groups complain that they are allocated too little money each year to carry out what they have planned.

Women also stand for office in the national and provincial elections; and in a very few cases women have been elected to the national and provincial parliaments. This is a clear indication of general perceptions and attitudes of men and women in Papua New Guinea to women in the political arena.

In the bureaucratic hierarchy, very few women have been appointed to high positions in government departments or statutory organizations; and hardly any women sit on the various government boards where they could bring women's views to decision-making. However, a woman lawyer has been appointed to head the National Law Reform Commission. Since taking office, she has worked hard to change the laws of Papua New Guinea to protect women against violence and to foster the development of women in the country. Women's groups are working with her and are aggressively carrying out awareness campaigns in all parts of the country.

In the private sector, hardly any women hold senior managerial or middle management positions. Most educated women in Papua New Guinea are found working in the social welfare division of the labour force. Women are also teachers, nurses, clerical and secretarial workers and tellers in banks. Very few women hold higher positions than these.

The churches were involved in women's development activities much earlier than the state, but their approach differs philosophically from that taken by the state. Churches have been promoting and supporting women to be good mothers by helping them to develop Christian values and positive attitudes towards themselves, their families, their community, their church and their nation. While the state promotes and supports women's activities which are by nature political, the churches seek to instill in them those skills and habits which can foster efficiency and healthy community living.

In the Evangelical Lutheran Church of Papua New Guinea no woman holds any middle or top-level managerial positions in the national church hierarchy. Nor do we have ordained women pastors. We do have women taking theological courses as part of a three-year parish worker training programme in one of our three seminaries, but they are not allowed to graduate as pastors. Some women's groups in the church have taken the position that women should be allowed to go to the seminaries to become pastors, but the view of the church as a whole on this is a conservative one.

* * *

Violence against women in Papua New Guinea thus takes the forms of physical violence and discriminatory decision-making. This is deeply rooted in the traditional perception of women held by the male population in the country, reinforced by the Judaeo-Christian tradition. This situation is aggravated by the increased use of alcohol and marijuana throughout the country.

Because of this, we have an imbalance of development opportunities between the two sexes in Papua New Guinea. I believe there is still a long way to go before the population of the country as a whole changes its general perception of women, seeing them as *partners* to men and recognizing that they do have similar strengths and abilities.

14. The Philippines
Dissent of the Migrant Women

NENA GAJUDO FERNANDEZ

What's in a name?

What was the last name
you remember
or must have uttered
when the thread
of consciousness snaps
and a gangrene
of nightmares
altered
the reality
of rose
coloured clouds
and a whirlpool
of faces
and events
in painful remembering
echoes
a name
your name
but could not
recall in moments
of lucid wander
and you thought
what's in a name
but a recollection
of rage
a merry-go-round
of tortured
tenderness
malted kisses
warped caresses
and the desire to fly
sensed
much stronger
than a promised
surreal orgasm
as voices are heard
in frenzied rhythm
familiar names
lost
in muffled cries
and hope
lie
in distant shore.
home then
was a pit
of nothingness
a refuge
of disjointed
reminiscence
a bale of threads
snapping
as you summoned
the gods
to end the game
without a name
but there was
no one
to call
by any name.

Sad stories abound of women migrant workers from the Philippines. Among domestic helpers and entertainers — the most common jobs for women who leave their country to find work elsewhere — maltreatment is common, rape is kept silent, dead bodies leave unanswered questions. Those who come back with severe mental illness create a disturbing picture of untold abuses. The poem "What's

in a Name?" was motivated by witnessing the return home of a Filipina woman, mentally ill, who worked as a domestic helper in Jeddah, Saudi Arabia.

Sylvia dela Cruz (not her real name) was referred to Kanlungan Center Foundation, a crisis intervention centre for migrant workers, by the emergency medical division of Manila International Airport. The referral was accompanied by a short note: "Endorsed patient: Sylvia dela Cruz, 34 years old, arriving from Jeddah on flight SV390. She was brought to the clinic by SV representative... due to her estranged behaviour. Impression: Paranoid."

Coming home with a mental illness may not quite be the order of the day for Filipina women migrant workers, but the number who do is alarming, as is the increasing number of "suicide" cases with telltale signs of foul play. Indeed, the realities migrant workers face are common knowledge: maltreatment, delayed or non-payment of wages, rape, murder and racism. And most of the victims are women.

The "feminization" of labour migration

The 1960s and 1970s witnessed the beginnings of the exodus of Filipino women to work in foreign countries. Thousands of women, mainly at first from the medical profession, sought greener pastures in North America and Europe. This was also the time of student activism in the Philippines. Under martial law, the foundations for an export-led industrialization were laid. Human labour, like other exportable commodities, became a lucrative source of dollar earnings.

In the 1980s the labour-export industry took shape. In 1982 the government established the Philippine Overseas Employment Administration (POEA) to design a comprehensive labour-marketing strategy and to dispatch marketing missions abroad. Under the regime of Ferdinand Marcos, overseas employment was touted as a stop-gap economic measure; today, under the administration of Fidel Ramos, this stop-gap economic measure is now called a "temporary economic measure". Meanwhile, the economic landscape has continued to bleed.

This set the stage for women to leave the confines of the bedroom and the kitchen. Aside from being the perennial housekeeper, the woman also had to work and earn. During these years the women's liberation movement gained ground in Asia, though whether entering the labour market under such circumstances may be construed as emancipation is another question. The number of women migrating for economic reasons grew to alarming proportions. Between 1975

and 1983, women accounted for about 30 percent of overseas contract workers; by 1987 the female percentage had risen to 47.

In 1992 the estimated number of Filipino migrant workers, including undocumented or illegal workers, was 4.5 million, about 49 percent of them women. In some countries, the great majority of positions held by migrant workers are as domestic helpers or entertainers, jobs mainly for women. There are more than a 100,000 Filipina women working as entertainers in Japan. Hundreds of thousands work as domestic helpers in Hong Kong, Singapore, Canada, Malaysia, the Middle East and Europe. Most of the women who work as domestics, particularly in Europe, have an above-average education, and many have finished college. Many in fact are teachers and nurses. To a large extent, Filipina women have replaced women from Turkey and the Mediterranean region as domestic servants in Europe.

Of the European countries, it is in Italy that the largest number of Filipina women work as domestic helpers. The Filipina Women's Council, an organization based in Italy, cited the presence of about 112,000 Filipina women, including the undocumented. Nearly 70 percent of them are between 21 and 30 and two-thirds have either begun or completed college education. While migration is reported to be positive in terms of earnings, professional demotion, particularly of those with a diploma or college degree, is common. Researchers confirm that professional mobility is practically non-existent among the Filipina women. Change of employer is frequent, but not of occupation. According to Italian law, authorization to work is valid for two years and applies only the particular activity for which the authorization is granted. After two years, however, such authorization is renewable for twice its term. [1] Hence, in Italy, a domestic helper is a domestic helper for ever and ever.

In recent years Europe has been closing its doors to legal immigration from the third world. While European unification is officially defined as allowing free movement of persons and merchandise inside the common territory, in reality Europe is creating almost insurmountable barriers to foreigners who wish to apply for residence and work permits. This is true even for Filipino women married to European nationals.

Filipino migrant workers in the 1990s

In 1991 the Philippines government announced with pride that a total of 615,019 workers were deployed in various parts of the world,

going on to note that "an all-time high of US$2.5 billion was remitted through the banking channels, making contract migration the biggest single dollar earner for the economy, even surpassing earnings from apparel (US$144.7 million) and electronics (US$143.76 million)". [2] Although the Middle East remains the main traditional market for contract workers, the skills picture has been altered, according to the government. Women now work alongside men in maintenance projects, health-care and the service sector. In the service sector, the bulk are domestic helpers and entertainers: in Japan alone there were 95,353 domestic workers and 45,899 entertainers in 1991.

The prospects for women in terms of overseas employment thus remain largely the same — domestic helper or entertainer. The government admitted that statistics for the first six months of 1991 showed that the skills most in demand were: domestics, dancers, unskilled labourers, janitors, nurses and performers.

Even the government concedes that Europe and North America are close to reaching the saturation point in terms of receiving foreign workers. Consequently, it looks to the "Asian Tiger" economies of Taiwan, Singapore, Japan, Malaysia and South Korea to sustain the pace of the overseas employment programme. What is alarming about this is that most of these countries are considered high-risk destinations for women migrant workers. Equally disturbing is the profile of women entering the labour market. The women may be from 14 to 60 years old, either single or married, schooled or unschooled.

Sylvia dela Cruz may be seen as a typical migrant worker who opted for a position as a domestic helper overseas rather than pursue a college education, since graduating from college does not necessarily mean a better future at home. Opportunities are lacking, particularly for women. For a while she worked in Singapore as a domestic helper; hence, maltreatment was not foreign to her when she applied for employment in Jeddah — again as a domestic helper.

In Jeddah, her employer took notice of her. He made her embrace his religion. According to Sylvia, they married, but the marriage was not legally processed. Sylvia gave birth to a baby boy in Egypt. But she was never allowed to see her son. From the hospital, Sylvia was drugged and sent back to the Philippines, arriving in July 1992, highly disoriented and heavily sedated.

After a few months she recovered and decided to try to find her child. She was hoping against hope. She knew the odds. She knew that any child born of an Egyptian father is an Egyptian citizen and

cannot be taken out without the father's consent. She knew she would have to prove that she was morally and financially capable, and that custody of her child might be awarded to her only if she resided in Egypt and agreed to bring the child up as a Muslim. For Sylvia, all this was next to impossible.

After a year, Sylvia was sent back to the mental hospital.

Global division of labour

Historically, labour migration from the Philippines is not a new phenomenon, but the present migration is remarkable in terms of numbers. The Philippines ranks as one of the highest peddlers and suppliers of manual labour in the world, along with Bangladesh, India, Korea, Pakistan, Indonesia, Sri Lanka and Thailand. Among these countries, Bangladesh stands out by having put a virtual ban on the migration of unskilled and semi-skilled female labour.[3] The global service industry is crawling with humanpower from third world countries. The positions available for foreign workers are those which are shunned by nationals of the wealthier and more developed countries — low-paying jobs, often difficult, dirty and dangerous, but necessary for further development of the country concerned.

Occupying the bottom rung of the service industry ladder are the women, who, as we have seen, work mainly as domestic helpers and entertainers. The human rights condition of foreign workers, particularly women workers in the Kingdom of Saudi Arabia, was the subject of a study by the Minnesota Lawyers International Human Rights Committee, which included a painful description of a domestic servant:

> Female domestic servants from developing countries are often obliged to endure truly slave-like conditions. Their employers often do not permit them to leave the house. Many are malnourished, forced to work up to 18 hours a day — every day — and subject to physical and sexual abuse. Domestic servants who escape from abusive employers are detained by the government and may be held in jail for up to several months before being deported. Some are obliged to return to the abusive employers.[4]

During her counselling period Sylvia dela Cruz evaded the issue of wages. It was never established whether she in fact received any form of wages or financial support — before, during or after she was deceived into what looked like a marriage.

It is commonly accepted that richer countries are in dire need of the cheap manual labour that poor countries have in abundance.

Trading is facilitated through the assistance and intervention of governments and private agencies. But neither the governments nor the private agencies ensure the protection of the migrants' rights and welfare.

A blood-stained tapestry

Simone de Beauvoir was correct in saying in *The Second Sex* (1956) that "there is no other way out for woman than to work for her liberation". But for women from the Philippines or other poor countries the question arises: at what price and in what way? More than 100,000 Filipino women are working as entertainers in Japan and elsewhere in the world, including the remotest parts of Africa. Needless to say, the jobs they occupy strengthen gender oppression, in which women become commodities and sex objects.

What kind of emancipation can a job in the service industry promise? At one level, a position as a domestic helper or entertainer is a job like any other job which people do to earn money. It would seem that there is nothing to be ashamed of, particularly if one's own country is unable to provide decent jobs locally. But what about one's rights — if indeed one has any rights? Are *any* rights guaranteed in the labour codes of either the labour-exporting or labour-importing country? Who regulates the number of working hours, days off, living conditions, salaries and other amenities necessary to keep body and soul together? Raymond Bonner quotes the comments of a Kuwaiti human rights activist on why domestic helpers are maltreated there: "First, it is because they are women, and women are mistreated generally in Kuwait. Second, because they are maids. They are lower-class, and people exercise power over them. And the woman employer often mistreats the maid the way she is mistreated by her husband."[5] The repatriation of some 400 runaway Filipino domestic helpers from Kuwait during 1993 has provided a graphic indication of their condition. In the United Kingdom, a spate of news reports on the harrowing condition of domestic helpers proved enough to reactivate a largely dormant anti-slavery movement.

If the government's overseas employment programme is keeping the Philippines economy afloat, it is also providing a gateway for the more sinister trafficking of women. Many women are lured to work overseas as maids, waitresses and in other jobs, only to fall into prostitution. Many others are trapped in an infernal environment because they have sealed their fate in a stamped envelope — the so-

called mail-order brides — clinging to promises that the families they leave behind will be financially provided for.

Luz, another young woman referred to the Kanlungan Center Foundation, married a German national after exchanging letters with him. The introduction was facilitated by a friend who had married a German through an agency. Luz was promised many things — most importantly to her the adoption of her three children. They lived on a farm in Germany. She was made to milk 50 cows and tend a large potato patch, as well as cooking, doing the laundry and all the other household chores. She was given DM 100 a month as a personal allowance. Luz lasted for a year-and-a-half before she asked for a divorce, and before it was granted she had to sign a document waiving her rights to any of her husband's properties. Luz stayed in Germany for a total of seven years, always on the run for want of legal papers, before she finally decided to go back to the Philippines.

While it is true that worldwide activism gave birth to the emancipation of a number of women, particularly in the highly industrialized countries, the repercussions for women of third world countries need deeper study and concern. While a number of women have been able to claim their rightful place in the corporate world and in the factories, it is women from poor countries who are filling the vacuum that these "emancipated" women have left.

The tapestry of women's emancipation is far from being woven; and already the threads are stained with sweat, blood and tears.

NOTES

[1] Graziano Battistela, CS, *Filipino Women Overseas Contract Workers: At What Cost?*, Beltran, de Dios, 1992.

[2] Philippines Overseas Employment Administration, *Annual Report 1991-1992*.

[3] Asian and Pacific Development Centre, *The Trade in Domestic Helpers*, 1989.

[4] Minnesota Lawyers International Human Rights Committee, *Shame in the House of Saud*, 1992.

[5] Raymond Bonner, "A Women's Place", *The New Yorker*, Nov. 1992.

15. United Kingdom
Women and Nonviolence — A Greenham Approach

DI MCDONALD

Greenham Women's Peace Camp was set up in 1981 on Greenham Common near Newbury in the south of Britain. Nearby was a military base used by the United States between 1983 and 1987 as one of five European sites for its ground-launched nuclear cruise missiles.

Despite massive rallies against these missiles and wide dissent towards government policy in the mid-1980s, the conventional wisdom was that actively opposing it was a threat to the security of the state.

In the end, women's protest was one of the factors which led to the ratification in 1988 of the Intermediate Nuclear Forces (INF) Treaty between the then-USSR and USA. But the Women's Camp continued as a women's community for change until January 1994, by which time the base had been abandoned by the military. The nuclear bunkers are now derelict, and the natural plants and trees of the common are reclaiming the land.

Violence and nonviolence: the Greenham experience

Common to all Greenham women is that we were and remain unconventional. As in any culture, this brought us into conflict with a conservative society which felt threatened by anyone "different". We were spat upon, people crossed the street to avoid us and many shops refused to serve us. National newspapers reviled us, supporting the worst prejudices and justifying the actions of rage: "*Ratepayers Against Greenham Encampments!*" Vigilantes attacked us, and a night watch became essential. What hurt most was that women who were against us were denying something in themselves.

The local Conservative council tried everything to remove us, but it was at the hands of the police that we experienced the most physical violence. Women were regularly dragged painfully by police, shoved, manhandled, rugby-tackled and arm-locked. Some women were pushed down road embankments in the dark. One was thrown out of a slowly moving police van into the path of a missile convoy. We experienced the physical power and dominance of men which many of our sisters bear, and we saw the clear connection between this personal violence and that of the nuclear state which it protected.

Amid this atmosphere appeared the Newbury Camp Support Women. They provided all that we lacked: baths, telephones, recognition and comfort. They were a lifeline to the outside world. Newbury Quakers, persuaded by their women Friends who visited and supported the camp, built a shower and laundry room for our use. It was a van-ride away in the town, but served us well for many years. This was nonviolence in practice.

"Nonviolence" is used to mean very different things — ignoring conflict, seeking a quiet life, collaborating with evil in order to avoid confronting it. [1] Usually it is defined along a spectrum from not being the first to start a fight to not responding to provocation with force to refraining from meeting force with force to not lashing out in self-defence to not retaliating. Nonviolence also means no verbal abuse when under physical or verbal attack. Nonviolence may require seeing past the hateful action or word to the person behind it — who is not hateful, but often full of hate. To be really nonviolent means not humiliating or hurting anyone at all.

Nonviolence is often seen as a tactic that is to be rejected when it fails to stem violence. Yet properly understood, nonviolence becomes the most powerful force for change. If we abandon it and fight, we perpetuate the cycle of violence and have to start again at moving away from a battleground towards the common ground we wish to build.

But violence is a spontaneous reaction to threat. It takes time, talk and reflection to develop alternatives and nonviolent responses. The privilege of exploring nonviolence as a means of resistance in the comparative safety of a rich Western country was, and remains, an opportunity not to be missed.

Behind violence we find power and hate, and behind hatred, fear. Before we can embrace nonviolence with confidence, therefore, we have to address our own fear. We also have to be sure we are not

looking for power "over" anyone. The concept of nonviolence is difficult enough to establish in the soft protection of debate between like-minded people, but the real test comes once you start taking action.

Women have the basic tools to make a start on addressing violence by nonviolent collective action. In response to the initiative of the Life & Peace Institute in Uppsala, a small group of Greenham women were spurred to evaluate our experience; to look at how and why Greenham evolved as it did; to look at what made it work and what it gave to women; to understand what were our mistakes and how our experience can be shared. Greenham changed the lives of hundreds of women. It had an even wider influence in our local communities, in the Green Movement, in the church, in Quaker and peace groups.

Our first principles were a commitment to nonviolence and women only. We did not claim to speak for any other woman, only for ourselves. There were no representatives or "spokeswomen", no leaders: "all the stars were in the sky". We struggled to find new ways of respecting and valuing each other; to interconnect and enjoy the solidarity of women everywhere; to gain a real understanding of what nonviolence is, and to use it.

Hundreds of women learned the principles and practice of nonviolence at Greenham. It changed from a tactic to a way of life, a sustainable system of recognition of the other not based on religion or rules. Women had the opportunity to try out their new thinking, to make mistakes and watch others make mistakes, knowing we were aiming in the same direction. Some women found it incredibly painful to see their feelings of hate break through towards the military and police as well as towards the weapons. But we could rely on other women to rescue us with back-stroking and calming words while moving us away from the situation.

The consequences of our experience of empowerment living in an outdoor women's community have spread far and wide: within our own families and friends, to women in Britain and across the world. It may appear that we are failing to topple the monolith, but as women everywhere who take nonviolent direct action know, without their resistance things might be much worse. We put a brake on the worst excesses of dominant powers. But we have only started, and there is much to do. Fortunately this earnest desire to build a world fit to live in includes a lot of laughs: "If there's no dancing at your revolution, count me out."

Inherently nonviolent forms of society

Nonviolence began by distinguishing between selfishness and self-esteem. Self-esteem we value, for respecting yourself is the only solid basis for respecting others. Everyone at Greenham was expected always to be conscious of how she was affecting others. Thus martyrdom, self-negation and self-sacrifice were not encouraged. They breed resentment and anger, and are auto-violence.

We did not accept other people's "oughts" and "musts". The basis for nonviolent action must be voluntary. The other side of this coin is that all are expected to be responsible for their own actions.

Other concepts not valued highly at Greenham were success and failure, winning and losing, which are inherently conflict-producing. Creating — enabling positive change — was valued, as were sharing, non-exclusivity and mutual support. To be sure, we did exclude men, but that was only so that we could explore further. The "normal" (mixed) values are actually male values, not male/female ones, except to some extent in the home. Men cannot contribute to the reclaiming of the missing women's element.

Fear and cowardice are treated as normal and can be discussed. Anger is treated as a response to perceived injustice. It is the perceived injustice not the anger that needs looking at. Disputes among ourselves were not always resolved. The community could help by supporting obvious victims if there were any or otherwise by being the sort of non-judgmental space which allowed us to be honest with ourselves. We could admit to being wrong, to misunderstanding as well as being misunderstood. The expectation that people will not oppress each other means that when people feel oppressed, they are more able to have it out with their perceived oppressor directly. But the system only works if the accused is also given space to apologize and stop. In most cases apologies are seen as adequate compensation.

The more women are able to accept the mixture of "good" and "bad" in each other and in themselves, the less the "bad" has to be stifled, to erupt elsewhere in the form of violence.

Three things became clear at Greenham. First, nonviolence is a full-time commitment, not a coat you can put on when it feels comfortable. It informs every aspect of life. Second, we could learn nonviolence, and we could put it into practice towards the military. Third, combining the natural strengths of different women often leads to the most successful actions. Women to whom nonviolence came easily would spread their calm, while action strategists would press

home a tactical advantage (like getting into missile convoy vehicles if we reached them and found the doors unlocked). Add to this mixture wit, a sense of fun and a liberal dose of disrespect for authority, and you have the perfect recipe for undermining the secrecy and hatred essential to planning for nuclear war.

Actions were practical and symbolic at the same time. For example, from 1983 onwards the Greenham fence has repeatedly been cut down by women, sometimes in bits, sometimes in huge chunks. Cutting the fence was symbolic; using the hole to get into the base was practical! Hundreds of women were arrested, charged and fined for criminal damage. Many refused to pay and went to prison instead. Apart from keeping the fence-menders in a job, the money spent on trying to prevent this constant snipping was all to no avail. Elaborate sensors, lights, civil and military police, British and US soldiers, surveillance and infiltrators all failed to solve this one simple problem.

We were not a real threat in military terms. But because we succeeded in embarrassing the United States Air Force time and again, their aims and objectives became less impervious to criticism. Of course, we could have been shot, and on many nights that seemed how it would end. But we gambled on the belief that the US Air Force recognized that killing unarmed women in a country they needed to occupy would not do their image any good. Given their training, resources and massive military might, admitting that we were a serious threat would make them appear even more hopeless and incompetent. Yet we did not discount the personal risk of taking on the most powerful country on earth. Death is the business of the military, and we had no illusions that, if it suited them, we were expendable. Women faced this at different levels, but many said they would rather die standing up than live on their knees.

Another extraordinary thing we learned was to become our own lawyers. Women lawyers with a feminist perspective were happy to point us in the right direction. So we defended ourselves, facing long nights over law books and long days in court. We won some cases. Many others were dismissed which, but for our research and tenacity, the police might have gone on to prove. The most important case proved by women was that the base was illegally built on common land. That was the beginning of the end of the military occupation of the common. Defending our actions in law courts has been a continuous part of protest, and the skills learned have extended into other campaigns and to other protest groups.

Action at Buckingham Palace

Nuclear testing of new warheads for British weapons took place on the land of the Western Shoshone people in the Nevada desert, USA, until the temporary US moratorium in 1993. Women working on this issue had not only gone to the test site and delayed tests, but had mounted a brilliant information and publicity campaign to link the horror of new warhead development with the inherent racism behind the denial of Western Shoshone land rights.

Women have seen the issue of sovereignty over the land as a crucial part of the case against nuclear testing. Not only was the sovereign territory of another nation being abused, but the British government was claiming the "sovereign right" to test its nuclear weapons on other people. It was a small step for us to decide that the right person to address was Queen Elizabeth II and the right place to do so was in the garden of Buckingham Palace.

On the night of 5 July 1993 about twenty women from England and Scotland met in London. We camped in a garden, where we sat around a fire discussing the next day's action and linking up with old and new friends. There were a couple of ladders and a rope for climbing practice. We discussed the consequences of our actions: arrest, court cases and fines — and imprisonment if we chose not to pay them.

Our main concern was to make it clear that it was the issue of nuclear testing that drove us to this action, that it was not some silly prank to titillate the media. An excellent press release was prepared for sending to media outlets by telefax, and photographing the action was organized. Support women were as much part of the action as those going over the wall.

The next morning we drove to the Palace, where we stopped and women piled out of the van. The ladders went up. The barbed wire at the top of a gate was cut by the first women and the cutters were passed back down to the van. Other women followed up the two sets of ladders and disappeared from the street. No police had appeared, but by this time a car had driven up and the driver was using a mobile telephone. It was time to move the van; perhaps he would follow it rather than leaping out to grab the last women waiting at the bottom of the ladder for their turn to go over. He did follow, but gave up after a while.

Outside the wall there was a brief flurry of police activity with motorcycles and a foot patrol-officer. Then sirens and more cars, with

uniformed and plain-clothes police looking around the quiet street and at abandoned ladders. Meanwhile, on the other side of the wall women were spreading around the lake and lovely gardens, unfurling banners, unrolling placards and making their way across the huge lawn towards the palace.

Security police understandably panicked and called out the guards, who combine their task of protecting the queen with their role as a major tourist attraction, which involves wearing huge fur hats and red jackets and standing or sitting completely still for hours on end. By the time they had left their ritual pose to go running through the garden, sweating under their headgear and brandishing rifles, some women had sat down and were singing. Others had been leaped on by police terrified at the thought of their reaching the big house.

I was about to leave the street and drive off when I saw the press start to arrive. Uncertain whether or not to stay, I remember thinking, "What would the Western Shoshone people I've met want me to do?" I stayed. The crowd of journalists grew. I brought a beautiful banner from the van, and the press men and women with cameras and note-pads following me even helped to unfurl the red, white and blue banner: *"Royal Recognition for Western Shoshone Sovereignty"*.

I was arrested for conspiracy to commit criminal damage and taken to the same police station as the women arrested inside the palace grounds. Those of us who knew the score in police stations were not frightened or thrown off balance by the intimidating questioning, but some less experienced women had a hard time. They were physically hurt or hated being locked up, so there was a lot of singing and shouting through steel doors to support each other.

Then the news started to filter through to us that our action was the top news story of the day. Television, radio and the evening papers were full of it. Two women who were released without charge after getting separated from their arresting officers in the confusion were able to give press interviews and appear on television immediately. The rest of us were released on bail the next afternoon. Nothing could have prepared me for the rush of press as we came out into the sunshine from Bow Street Magistrates Court. At long last, women taking action against the military, against nuclear weapons and for the rights of ordinary people whom our government was abusing were taken seriously. There were front-page colour pictures in all the major newspapers. Local papers in the towns where the women came from gave similar coverage to the story of what women were willing to do

to publicize the far-reaching consequences of their government's nuclear war programme. Eventually the conspiracy charges were dropped, and we faced the less serious one of criminal damage.

I tell this story not only because it was the most well-publicized nonviolent direct action I ever expect to be involved in, but also to illustrate the lateral thinking of women. The Buckingham Palace action shows the strength of working together in a small group, without a leader. Every woman is free to take the initiative, take risks, be angry, shout, sing, disobey police and be adaptable. We are always looking for unexpected and unpredictable actions, even as part of familiar actions to blockade a military base or convoy. Women have wrapped a nuclear warhead convoy in a web of wool, popped a potato down a missile carrier's exhaust pipe and sat on blankets on a four-lane highway at 3:00 a.m. to prevent a convoy moving again once it had been stopped. Many other such actions have achieved our aim of publicizing the madness of threatening ordinary people like us with nuclear weapons around the world.

Cruisewatch

Cruisewatch was a network that monitored and tracked the US Air Force nuclear missile convoys. The minister of defence had claimed that these convoys of nuclear missile launchers would "melt into the countryside". They were driven to woodland in the south of England, covered in camouflage and prepared for attack. With such practical realities nuclear wars are planned.

The tracking, much done by Greenham/Cruisewatch women, enabled the protest to be taken to the dispersal sites up to 100 km. from the base. I do not think Cruisewatch would have developed into such a remarkably successful system of undermining military secrecy if it had not been for women who were prepared to take risks into the unknown. We really did not know whether we would be shot, intentionally or by mistake, especially by the US troops.

One of the first times we found the convoy, I drove a van full of women right up to the secret security compound. It was a wonderfully sunny day, with birds singing and tall grass waving across Salisbury Plain. Suddenly we heard the roar of tanks. One blocked our path forward; another closed in at the rear. From above a helicopter hovered so low that it clipped the roof-rack of the van before landing nearby. Soldiers leaped out onto the front of their tanks and aimed guns at us. After all this frenzied activity everything slowed down. It

was a pattern often to be repeated by excited troops and their commanders, but on that occasion we were pretty shaken in our battered minibus. Some women cried, others whooped with success, someone took photographs of the khaki legs on the tank bonnet in front of the windscreen. We locked ourselves in and waited. Eventually ministry of defence police turned up, and we were arrested, processed, held all day but never charged.

After this we used radios to keep in touch with each other when we went into the wild where the convoy had gone to hide from enemy satellite detection and from the British people. At the other end of the radio were committed women who were our lifeline to "the normal" world and to legal support. Theirs was the task of passing on the map grid-reference of the convoy's location. Then they would make sure someone would come to meet us at the police station and take us back to our vehicles.

As time went on, the combined efforts of Greenham women and Cruisewatch enabled people living in towns and villages along the convoy route to come out of their houses in protest as the convoy went by. The commitment to help others in voicing their dissent was not separate from taking our own actions. The crucial task was to predict the time and route of the return, when most people could get out, given a week's warning.

We were constantly driven by a sense of responsibility. If we did not find out what was going on, who would? We refused to let politicians and the military believe they were acting on our behalf. Familiar cries were "Not in our name!", and "Shame, shame on you!" There was a certain excitement about obstructing the military at the point of delivery; at the very place and moment of the threat to our sisters and their loved ones on the other side of Europe.

* * *

Greenham women are involved in many different campaigns now. They remain tireless in their struggle to make known the secret systems of repression, suppression, surveillance, nuclear weapons tests and warhead movements. In another place, in another time, we would do different things.

We still organize in small groups, linked by a loose network, consciously rejecting the large structure that a big organization would bring. "Nonviolence" and "women working together" have become

shorthand for all the ways of doing things described in this chapter. Greenham was always the women there rather than a place, although the common continues to be our spiritual home. Some of our sisters' ashes are scattered there, and many of us would want the same for our own. History is usually written by the victors, but there is no victory beyond knowing we have tried.

NOTE

[1] This personal testimony makes no claim to being an objective analysis of nonviolence as developed by Greenham women, or to be in any way representative of them. It is a view from one woman's perspective.

16. Vietnam

Nonviolent Activities to Prevent Violence

LE THI NHAM TUYET
MA THI PHUONG TIEN

The subject of this article is the search for positive measures to prevent cruel attitudes and behaviour towards women. The need to confront violence by nonviolent actions is not only our personal point of view, but also a lesson drawn from the historic traditions of Vietnam as well as its experience over many years.

The traditional Vietnamese concern to foster a united community spirit and a life and ethic of affection is summed up in proverbs such as "The citizens of the same country must sympathize with each other" or "If the husband and the wife are agreeable, they can scoop enough water to dry the Eastern Sea." The Vietnamese people know how to use flexibility against firmness, to take nonviolent actions against violence when solving conflicts in the family and among people.

Vietnamese women, like women the world over, are pushing for peace and justice in their communities. While women in many places have represented a force capable of changing society, in many other places they are being subjected to violence and cruel treatment. The struggle to protest against and prevent this is very important in maintaining a country's stability and fostering its development. It springs from a concern to protect the security and happiness of each individual and of each family. It is the responsibility of the whole society.

Violence in Vietnam

Vietnamese women in the past have faced the same situation as all other people. First of all, it was the plight of a people who lost their country. It was also the yoke of domination by the feudal regime of Nguyen. In that situation women suffered "two oppressions", for they

had to bear the additional exploitation of patriarchy, especially within the family. The man was the chief who had absolute power in the family, and the law did not recognize the right of women. "Man is respected; woman is disdained."

After the August 1945 revolution wiped out the social and economic bases of the feudal regime, a wave of democracy changed the appearance of the society and flooded into every family, resulting in a change of the quality of life and in the position of each family member. The liberation of the woman freed her from the lot of being the "slave of a slave".

Now in a family the man no longer has absolute power as he did in the feudal and colonial regimes. Equality among man and woman has been recognized by law. Every member of a family has the same material and spiritual rights, even the right to have a private economy. These rights have been respected. Women have the right as citizens to study, to work and to be well-treated. Fundamentally, it is this which has wiped out their former all-round dependence on men. The law has many provisions defining the rights of every citizen.

Yet despite the positive work of the authorities and the mass organizations on the basis of law and social ethics, violence continues to occur in families and society. Especially in recent years an increase of crises, clashes and even crimes have seared everyone's conscience. Murder cases are becoming the worry of the society. Sometimes cases of violence push women or children to commit suicide. Even in the case of rape of young girls, the victim is often as unwilling as the culprit to let anyone else know, making it very difficult to trace the extent of this type of violence. With that violence becoming a growing social problem, the whole society has the responsibility to protect family happiness, human beings and especially innocent women and children, whose dignity and lives are at risk in their own homes, at their places of study and work and on the street.

Nonviolent activities by women to prevent violence

The Women's Union of Vietnam is a large mass organization with more than 11 million members. Strictly organized from the centre down to the hamlet and village level, it functions as an advocate of the right to equality and protects and takes care of women's and children's interests. Its branches in hamlets and precincts play an important role in the reconciliation of conflicts and disputes.

The resolution of disputes and the prevention of violent behaviour, as well as efforts to ease the psychological burden of the people through counselling, magazine columns, confidential talks and measures to address economic tension have affirmed women's non-violent activities in preventing violence in Vietnam.

1. Reconciliation and counselling activities. Conciliation measures can be carried out between individuals, between individuals and the collectivity and between communities. Normally, conciliation between individuals is carried out first. For the Vietnamese the family is a very important and stable factor in all realms of life. The family is the first social environment for a human being and also the final one. The breakdown of the family is thus not in the interests of Vietnam. For the Vietnamese, violence in the family is not a particular problem for a single family but a general problem for the extended family, the village and the hamlet. In Vietnamese society the head of the family-line normally plays the central role of reconciliation. When conflicts arise between family members, they invite the head of the family-line to analyze the situation. The members normally obey the head of their family-line, and such reconciliation is more effective than administrative measures. Nowadays, owing to economic and social change, the role of the family-line and its head is diminished, but the character of the community is still stable, particularly in the rural areas.

Based on this tradition in Vietnam, "conciliation measures" are now considered one of the most important and effective means for limiting violence towards women. Conciliation centres, conciliation committees and conciliation teams have been formed. The "conciliation measure" is not an abolition of struggle or a tactic to compel women to show self-effacing behaviour in the face of cruel attitudes. On the contrary, it is a soft-mannered but resolute struggle, a non-violent action against violence. It is action to protect human rights and women's right to development. It contributes to limiting violent action against women's minds, their human dignity and their bodies.

The conciliation team takes the initiative of visiting women going through a difficult situation and ill-treated women. They work to help them to regain their happiness and to find equality through conciliation. For example, Mrs Bui Bich Thu, head of one conciliation team, helped to reduce the number of conflicts and cases of coarse behaviour in her area from 146 in 1989 to 84 in 1990 and 30 in 1991. The women's association has been a source of effective conciliation for ten

couples, three groups of husband, mother and daughter-in-law, and three cases of neighbours.

In Hanoi there are more than 1900 reconciliation groups with more than 6000 members, of whom the core come from the Women's Union, the Fatherland Front, the Ho Chi Minh Communist Youth Union and the Martyr's Union. In 1992 they had remarkable achievements: 1471 out of 2390 cases (61.5 percent) were reconciled. In Hanoi between 1987 and 1992, some 30,000 requests for divorce were sent to reconciliation groups, the court, the Women's Union and the Precinct and Commune People's Committees. Of these 16,292 were considered. Some precincts and communes have successfully reconciled 50 percent of the cases of family discord — of which 60 percent are related to violence in the family. Violence in families, especially of the husbands, played an important part in the cases of divorce. Court figures show that more than 70 percent of divorces in 1991 and more than 65 percent in 1992 involved a complaint of violence.

Reconciliation measures can also be applied by popular channels of information. President Ho Chi Minh said that "the revolution has brought an equality to everyone. Women are the daughters, sisters, wives and mothers accounting for a half of society. If they do not enjoy the rights of equality, the revolution has fulfilled only half of its task." To implement this teaching, several magazines have articles for women. For example, *Vietnamese Woman* regularly includes a column entitled "Confidence", written by Thanh Tam. *The Capital's Woman* has a column called "Converse", written by Tam Giao. These articles offer lessons on relations between the sexes. Many women have a difficult life — deceived by bad persons, abandoned by the family, beaten by their husbands, treated badly at work, experiencing unlawful action, pushed into prostitution. Their columns have made Thanh Tam and Tam Giao well-known confidants. They are the protectors, the defenders who support many mothers, wives and sisters with compassionate and upright hearts. Through these articles cruel actions towards women are firmly condemned and public opinion is influenced.

2. Reducing economic tension in the family. In some families which are poor, or have many children, low income, long illnesses, loss of production or loss of a job, violence appears. Although Vietnam has begun to go through a vigorous economic change recently, many difficulties still exist. The elimination of the system of subsidies and the strengthening of the economic role of the individual

household have, despite their positive aspects, also had some negative effects on family life. The heavy responsibility for production and business which once fell on the collectivity and the cooperative in rural areas is now being shifted to the family. This has an impact on every family member. Also, the clear differentiation which has developed between the rich and the poor is becoming a problem. In this changing situation violence towards women has increased.

Recently the Women's Union has launched a campaign on "women's mutual aid to improve the family economy". Its role is to help each other to find and choose a suitable form of production for each target group, to organize the exploitation of capital resources and to motivate mutual aid to lend money, seeds and other production requirements.

The provincial Women's Union of Lam Dong, Thai Binh, Ho Chi Minh City has had significant achievements in this movement. For example, in 1989 the Women's Union of Thai Binh province established 346 handicraft production teams. Four districts of Hanoi have organized 178 service teams. The Women's Union of Ho Chi Minh City has generated stable jobs for 2344 women and temporary jobs for 6513 others. The Women's Union has borrowed money from the state to make loans to poor families for production.

Such activities are creating a happier and easier life for many families, which can help to prevent unnecessary economic tensions in their relationships.

3. Education about civilized living and family happiness. Vietnamese women have a tradition of a upright and kind-hearted behaviour and a sense of responsibility, expressed through their simplicity, humaneness, fervent love and loyalty towards their husband and children.

The struggle against family violence is closely linked to the eradication of old and backward conceptions and the creation of new standards in family relationships. The Women's Union, women's organizations and Youth Union are trying to carry out education for a civilized and happy style of life. A strong public opinion condemning the violation of ethics in families, especially the beating of women and children and the bad treatment of old people, has been created. The mass media have sharply criticized the habits and practices which cause family violence.

The social evils which accompany domestic violence have been gradually eliminated in recent years. The recent shift to a market

economy has however created some negative phenomena: prostitution (into which young girls have been forced), drug addiction and robbery have polluted the social atmosphere. Indifference and irresponsibility have encouraged the committing of crimes. It is necessary to teach women at every level; they must have the knowledge actively to protect themselves, their children and their families.

However, preventing violence against women is not just a matter of the "hammer and axe" of the laws. The strong and effective arm is the "hammer and axe" of public opinion. Since there is already a respect for ethics and honour, the judgment of public opinion often carries more weight than the judgment of the law. "A monument will wear out in one hundred years; posthumous bad reputation will remain whole for a thousand years." Essentially, the use of the "hammer and axe" of public opinion is the use of nonviolent action against violent actions.

Many examples of "good men — good actions" and "families of culture" have been set up to motivate and encourage behavioural change. Every year the Women's Union associations of Vietnam review the patriotic competition movement which seeks to build a "civilized mood of living and a family of culture". Now many competitions have been launched to select "good propagandists" from the grassroots to the central level, and many courses on the improvement of reconciliation skills have been conducted.

All of these efforts are only at the first steps of a long itinerary in the struggle for bringing women back to their position of social dignity. We are marching forward to the 21st century. The woman's century is not a century where the power belongs to the women but a century of happiness and development for women — a development full of scientific and human character. We will choose our future, a future of nonviolence.

Contributors

Elizabeth G. Ferris is director of immigration and refugee program of Church World Service, National Council of the Churches of Christ in the USA, New York.

Corinne Kumar-D'Souza from India is general secretary of El Taller, a network of action groups with headquarters in Tunisia. She is the founder of the Centre of Informal Education and Women's Studies in Bangalore, India.

Ruth M. Besha is professor of linguistics at the University of Dar Es Salaam, Tanzania.

Jo Barter is a member of the Australian Nonviolence Network, in Melbourne, Australia. She works with the Women's Resource Information and Support centre, based in Melbourne.

Lynn Granke, a pastor, has served as national director for the division for parish life of the Evangelical Lutheran Church in Canada, with responsibilities for youth and outdoor ministry.

Joyce K. Umbima is director for Kenya Alliance for Advocacy on Children's Rights in Nairobi.

Gisella Haoses is director of Women Solidarity, a women's shelter and advocacy organization in Windhoek, Namibia.

Meena Poudel is a member of the feminist collective Women Acting together for Change in Kathmandu, Nepal. She is also a member of the Asian Women's Human Rights Council.

Shelley Anderson is on the staff of the International Fellowship of Reconciliation, Alkmaar, Netherlands.

Judy Towandongo is a social worker with the Centre for Social Concerns in Lae, Papua New Guinea.

Nena Gajudo Fernandez is on the staff of Kanlungan, a centre for migrant workers in Quezon City, the Philippines, coordinating the resource and advocacy programme.

Di McDonald is an activist against armaments and military use of nuclear power. She is active in the Greenham Common movement in the United Kingdom.

Both from Hanoi, *Le Thi Nham Tuyet* is director of the Research Centre on Gender, Family and Environment in Development, and *Ma Thi Phuong Tien* is with the Centre for Family and Women's Studies.